PAINTER'S QUICK REFER

Trees & Foliage

EDITORS OF NORTH LIGHT BOOKS

NORTH LIGHT BOOKS
CINCINNATI, OHIO
www.artistsnetwork.com

Published by North Light Books, an imprint of F+W Publications, Inc., 4700 E. Galbraith Rd., Cincinnati, Ohio 45236. (800) 289-0963. First edition.

Other fine North Light Books are available from your local bookstore, art supply store or directly from the publisher.

Library of Congress Cataloging-in-Publication Data

Painter's quick reference : trees & foliage / editors of North Light Books.

 p. cm.

 Includes index.

 ISBN 1-58180-615-9 (alk. paper)

 ISBN 1-58180-613-2 (pbk: alk. paper)

 1. Trees in art. 2. Leaves in art. 3. Painting--Technique. I. Title: Trees & foliage. II.

 Title: Trees and foliage. III. North Light Books (Firm)

 ND1400.P335 2004

 751.45'434--dc22

2004044968

Editors: Christina D. Read and Kathy Kipp
Designer: Karla Baker
Production Coordinator: Kristen D. Heller

Metric Conversion Chart

to convert	to	multiply
Inches	Centimeters	2.54
Centimeters	Inches	0.4
Feet	Centimeters	30.5
Centimeters	Feet	0.03
Yards	Meters	0.9
Meters	Yards	1.1
Sq. Inches	Sq. Centimeters	6.45
Sq. Centimeters	Sq. Inches	0.16
Sq. Feet	Sq. Meters	0.09
Sq. Meters	Sq. Feet	10.8
Sq. Yards	Sq. Meters	0.8
Sq. Meters	Sq. Yards	1.2
Pounds	Kilograms	0.45
Kilograms	Pounds	2.2
Ounces	Grams	28.3
Grams	Ounces	0.035

Introduction

WHEN YOU'RE IN A HURRY FOR PAINTING HELP, HERE'S THE BOOK TO COME TO FOR IDEAS, INSTRUCTIONS AND INSPIRATION.

This basic, easy-to-use reference features a large variety of trees and foliage for all seasons. It's a winning combination of "idea file" and "step-by-step demos" for painters of all skill levels.

This complete resource is full of trees, shrubs, leaves and grasses as well as inspiration for painting distant foliage. It's designed to give you lots of quick, fresh ideas for almost any painting project.

It's your own handy "library" that you can go to to "find it fast." Specially designed to be quick and easy to use, this book is arranged by subject matter. You'll find the projects painted in the three major mediums––acrylics, oils and watercolors. The number of steps per demonstration are kept to a minimum. There are no difficult techniques to master, no boring theory and no heavy-duty art instruction. Just lots of pictures and short captions!

The contributors include favorite North Light decorative painting and fine art authors, plus skilled landscape artists.

Table of Contents

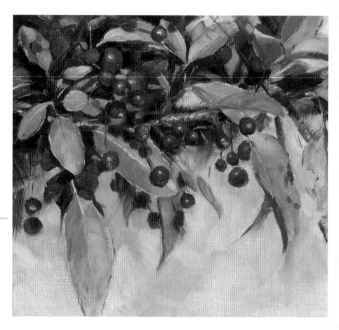

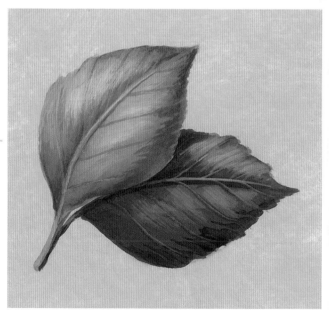

CHAPTER 1
Evergreens

Evergreens are one of the most popular and enjoyable trees to paint. This chapter features many different types of evergreen trees, shown at different seasons of the year.

You'll also be able to experiment with different types of brushes; plus, there are two examples of painting with sponges. Here you'll be able to find inspiration so you can add these beautiful trees to your current or future project.

Winter Pines
SHARON BUONONATO

MEDIUM: *Acrylic*

COLORS: *DecoArt Americana: Jade Green ◆ Plantation Pine ◆ Evergreen ◆ Plum ◆ Yellow Ochre ◆ Hi-Lite Flesh*

BRUSHES: *Sharon B's ³⁄₈-inch (10mm) blade ◆ no. 4 round ◆ no. 1 liner ◆ 1-inch (25mm) flat*

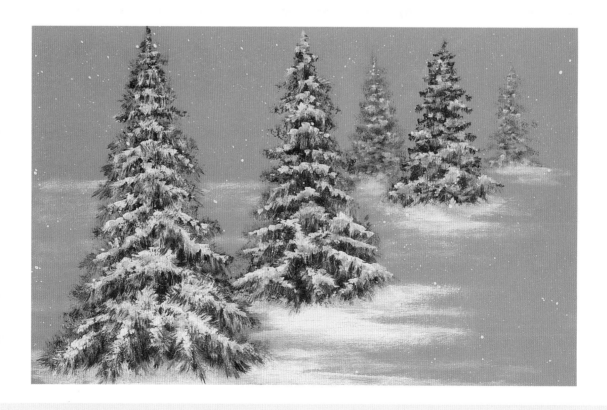

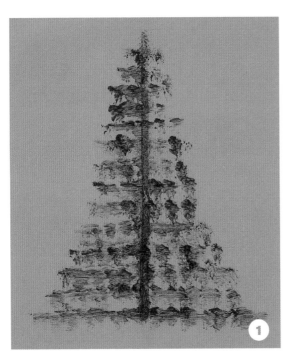

1 Paint the trunk line with Plantation Pine and the no. 1 liner. Using the tip of the ³⁄₈-inch (10mm) blade and Plantation Pine, tap on the branches to form a triangular shape.

2 Fill in the tree with Plantation Pine branches painted the same way.

3 Paint additional branches in the center of the tree in the same way with Evergreen to darken the shape.

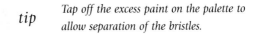

tip *Tap off the excess paint on the palette to allow separation of the bristles.*

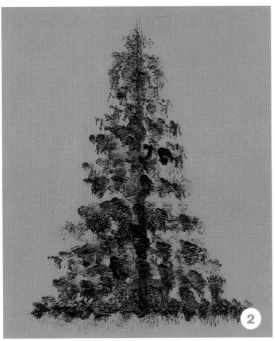

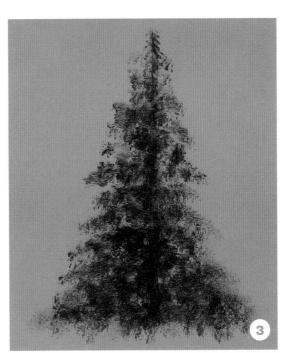

Winter Pines

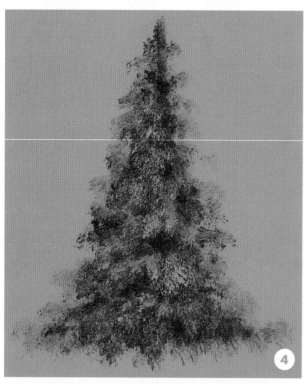

4 Tap on a few Jade Green branches in the center of the tree using the tip of the ³/₈-inch (10mm) blade.

5 Add a few highlights of Yellow Ochre in the same way.

6 Distant Pine: This illustration represents a distant pine tree painted the same way on a dampened surface. By first applying clean water with the 1-inch (25mm) flat, then proceeding to paint the tree, it will appear softer.

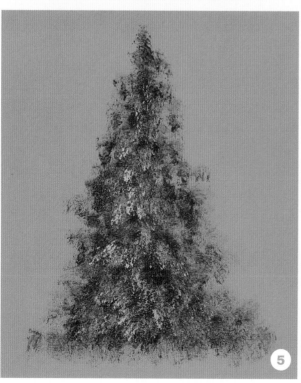

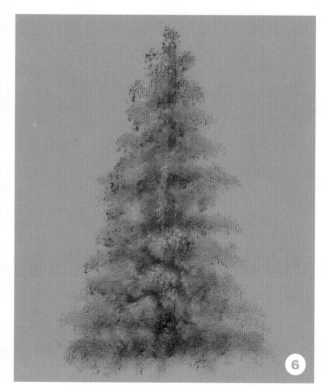

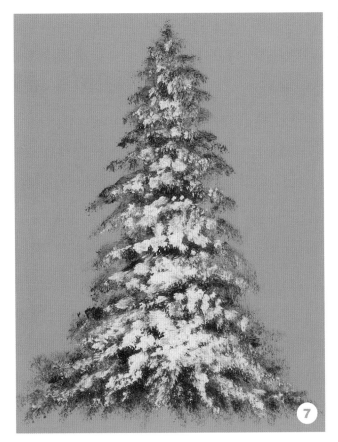

7 Foreground Pine: This illustration shows a larger foreground pine with snow added to the branches. Tap on Hi-Lite Flesh, using the tip of the ³/₈-inch (10mm) blade to form clumps of snow on the center branches. Trail off the remaining paint to produce delicate snow on the outside branches.

8 Foreground Pine: Drybrush Hi-Lite Flesh needles with the chisel edge of the ³/₈-inch (10mm) blade. Tap off any excess paint on the palette to allow bristle separation. Then pull the needles down from the snow clumps. Add a few Plantation Pine needles the same way, poking in all directions, including the tips of the outside branches. To cool the snow clumps, paint here and there with very thin Plum, using the no. 4 round.

Snowy Evergreens

LAURÉ PAILLEX

MEDIUM: *Acrylic*

COLORS: *White ◆ Dark Green ◆ Raw Sienna ◆ Burnt Umber ◆ Payne's Gray*

BRUSHES: *angular bristle foliage ◆ liner*

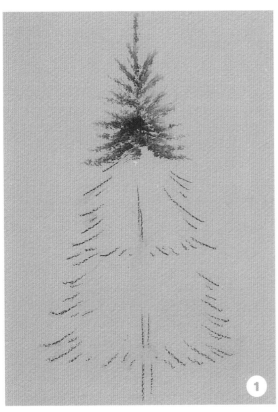

1 Load the angular bristle foliage with Dark Green, pick up White on the long bristles and blend colors into the brush. Tap branches onto the tree top, keeping the Dark Green value toward the tree trunk.

2 Continue filling out the branches in the middle section of the tree, reloading the brush often to maintain consistent texture. Leave some open spaces near the trunk to allow light to pass through.

3 Fill out the bottom section of the tree, fanning the lower branches down and outward from the trunk.

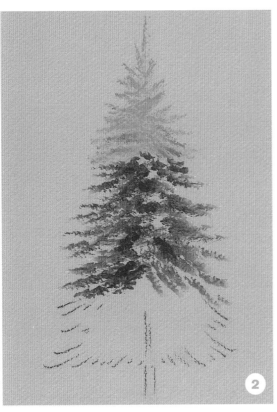

Snowy Evergreens CONTINUED

4 Now, place the trunk and main branches with brown hues.

5 Three Trees: Load the angular bristle foliage brush with Dark Green, pick up White on the long bristles and blend colors into the brush. Tap branches onto the foreground (center) tree keeping the Dark Green value toward the tree trunk and the lighter value facing outward.

6 Fill in background trees. Establish the trunks and main branches with light and dark brown hues.

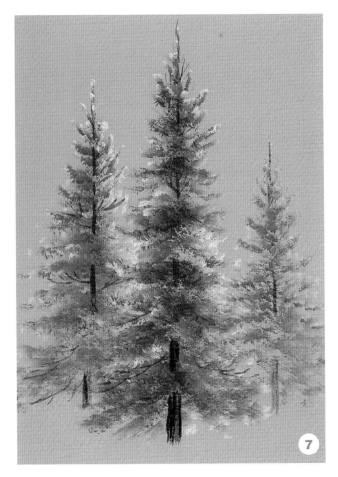

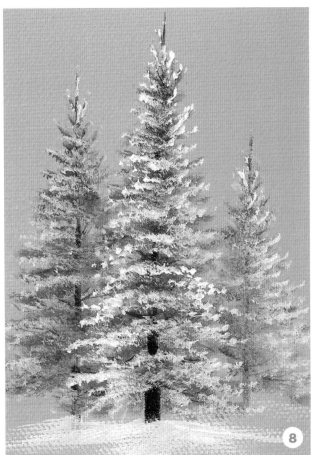

7 Add inner shadows near the trunk and separate tree forms with a wash of Payne's Gray. Detail the trunk with Burnt Umber + Payne's Gray.

8 Highlight foreground tree branches with thick White loaded onto the long bristles of the brush. Touch soft highlights on the background trees. Place heavy snow at the base of the tree.

Fan Brush Evergreen for Beginners

SANDY AUBUCHON

MEDIUM: *Acrylic*

COLORS: *DecoArt Americana: Black Green* ◆ *Avocado* ◆ *Olive Green* ◆ *White*

BRUSHES: *no. 2 bristle fan*

1 Use the chisel edge of the no. 2 bristle fan brush, filled with Black Green, for the tree trunk. Add more Black Green to the brush. Use only the corner of the brush to lightly dab in the top area of the tree. Gradually use more of the brush until you are dabbing across the tree. You should be using the full width of the brush about halfway down the tree.

2 The tree will look scrawny until you repeat this tree dabbing one more time. Use the same color. You should still be able to see through the tree here and there.

3 Add Avocado to the dirty brush and dab this middle value across the right two-thirds of the tree. Do this only once.

Fan Brush Evergreen CONTINUED

4 Add Olive Green on the dirty brush. Apply this lightest color about two-thirds across the right side of the tree, using a dabbing technique.

5 Use the dirty brush and rub gently across the bottom of the tree to help set the tree down into the ground area.

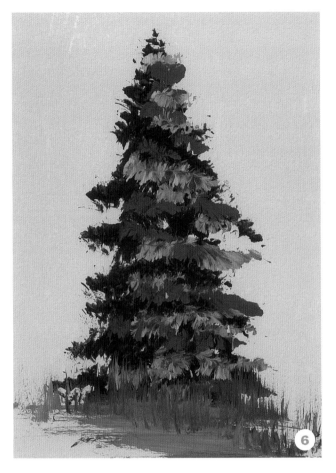

6

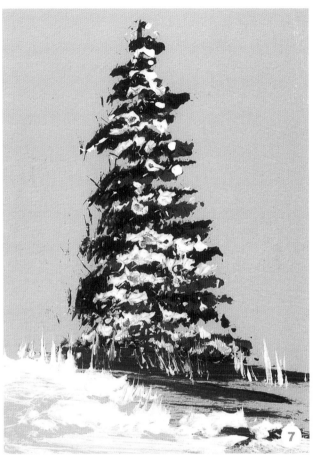

7

6 While still wet, use the dirty brush to pull up some short grasses. Keep the handle of the brush vertical to the surface.

7 To change the tree to a snow scene, simply clean the brush after step 6. Fill the brush with clean White and apply it as a highlight. Then rub to set in the snow. Again, pull up short grass with the same fan brush.

Hemlock Spruce

SHARON BUONONATO

MEDIUM: *Acrylic*

COLORS: *DecoArt Americana: Jade Green • Plantation Pine • Evergreen • Sable Brown Asphaltum • Yellow Ochre*

BRUSHES: *Sharon B's ³⁄₈-inch (10mm) blade • Sharon B's ³⁄₄-inch (19mm) blade no. 1 liner • 1-inch (25mm) flat*

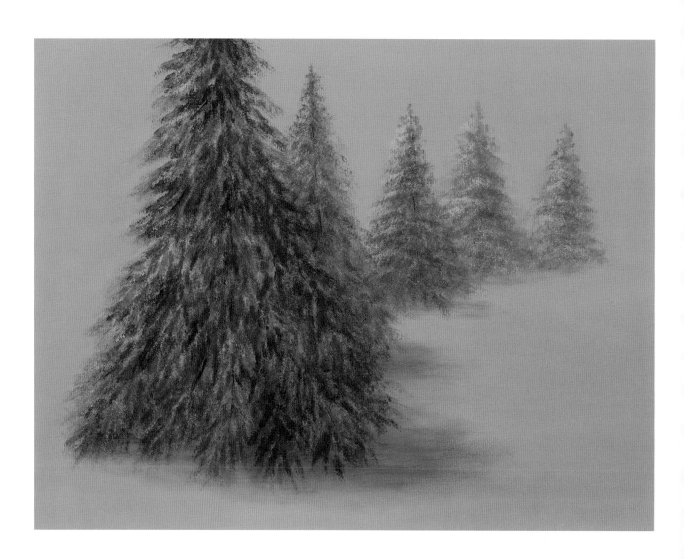

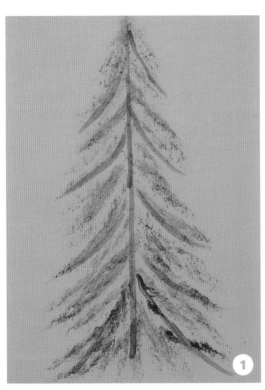

1 Form the center trunk line and branches with Plantation Pine on a no. 1 liner brush. Using the chisel edge of the ⅜-inch (10mm) blade and Plantation Pine, tap on the branches between the line work.

2 Using the same technique and color, fill in more branches. Keep the airy appearance.

3 Repeat the same technique with Evergreen to darken the tree form.

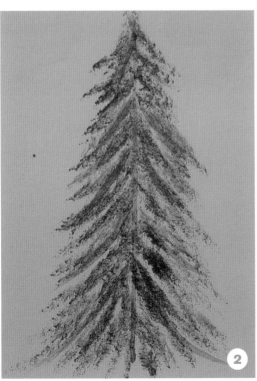

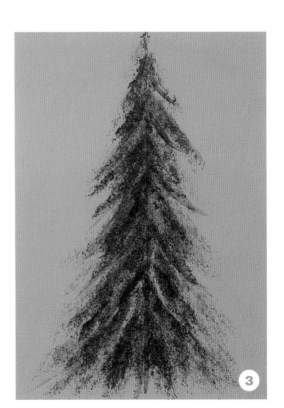

Hemlock Spruce CONTINUED

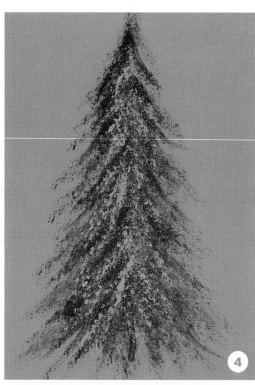

4 Highlight the center of the tree with Jade Green branches, using the chisel edge of the ⅜-inch (10mm) blade brush.

5 Using the same technique, add a few Yellow Ochre highlights on top of the Jade Green branches. Paint a few Sable Brown branches in broken linework, using the no. 1 liner.

6 Distant Hemlock: This illustration represents a distant Hemlock Spruce tree painted the same way, but on a dampened surface. By first applying clean water with the 1-inch (25mm) flat brush and then proceeding to paint the tree, it will appear softer.

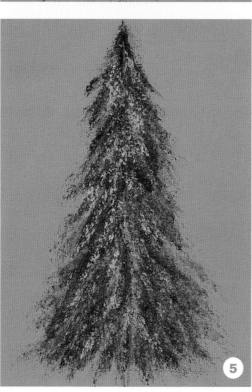

7 Foreground Hemlock: This illustration shows a foreground Hemlock Spruce painted the same as in the previous steps, using a ¾-inch (19mm) blade brush. A few branches of a cool sky blue color have been added to the right side of the tree. The Sable Brown branches have been detailed with Asphaltum linework, using the no. 1 liner.

8 Foreground Hemlock: This foreground Hemlock Spruce is completed by adding more Evergreen branches mainly on the center and right side, using the chisel edge of the ¾-inch (19mm) blade brush. This will also push the brown branches into the tree and reduce the highlights, providing a more dimensional look.

Arizona Cypress

THEODORE C. TSE

MEDIUM: *Acrylic*

COLORS: *Hooker's Green Light* ◆ *Raw Umber* ◆ *Titanium White* ◆ *Yellow Ochre*

MATERIALS: *natural sponge*

Colors

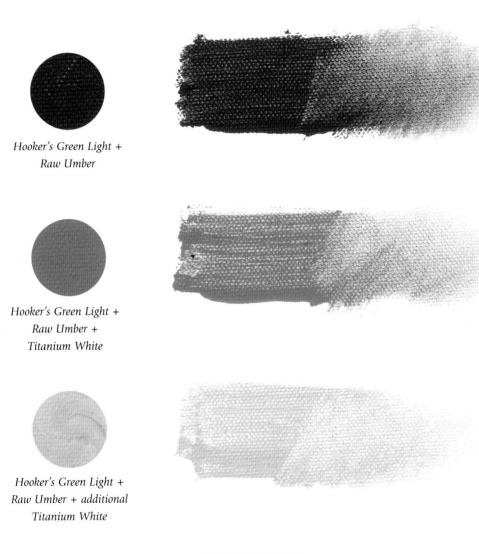

*Hooker's Green Light +
Raw Umber*

*Hooker's Green Light +
Raw Umber +
Titanium White*

*Hooker's Green Light +
Raw Umber + additional
Titanium White*

*Hooker's Green Light +
Raw Umber +
Titanium White +
Yellow Ochre*

Arizona Cypress CONTINUED

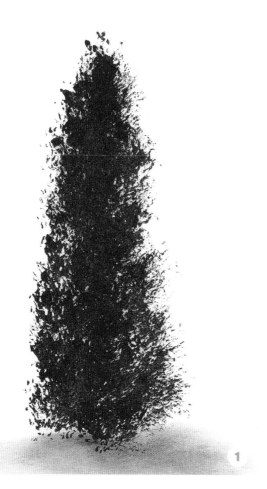

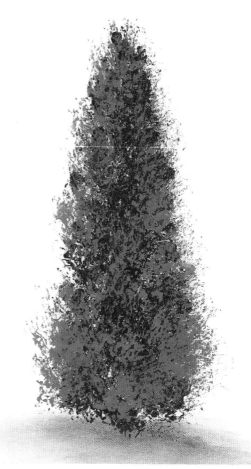

1 A natural sponge is all you will need to paint this beautiful Arizona Cypress. Working dark to light, block in a cone shape by dabbing a dark mixture of Hooker's Green Light and Raw Umber.

2 Add a little Titanium White to the first color and loosely dab this medium hue randomly over the dark shape.

3 Add more Titanium White to the color from step 2 and dab in where the light areas will be.

4 For sparkling highlights, mix Yellow Ochre into the color used in the last step and slightly dab over the lightest areas.

White Pine

SHARON BUONONATO

MEDIUM: *Acrylic*

COLORS: *DecoArt Americana: Jade Green ◆ Plantation Pine ◆ Evergreen ◆ Sable Brown*
Asphaltum ◆ Raw Sienna ◆ Black Plum ◆ Yellow Ochre

BRUSHES: *Sharon B's ⅜-inch (10mm) blade ◆ no. 4 round ◆ no. 1 liner ◆ ¼-inch (6mm) angular*

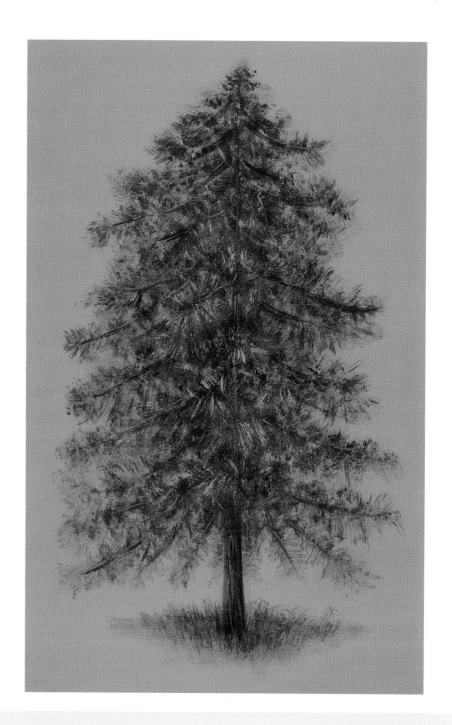

1 Base paint the trunk and branches using Sable Brown and the no. 4 round and the no. 1 liner. Shade the tree with Asphaltum linework, using the no. 1 liner. Highlight the same way, using Yellow Ochre.

2 Wash over the tree with Raw Sienna to darken the trunk and branches, using the round brush. Float Black Plum on the right side of the tree trunk, using the 1/4-inch (6mm) angular. Drybrush the needles onto the branches using the tip of the 3/8-inch (10mm) blade brush with Plantation Pine.

3 Using the chisel edge of the 3/8-inch (10mm) blade brush and Evergreen, tap on needles starting in the center of the tree. Follow the branches out towards the tips. Fill in the tree shape with extra Evergreen branches.

4 Drybrush a few needles of Jade Green, using the tip of the 3/8-inch (10mm) blade brush. Start pulling quick strokes on the center branches in all directions. Repaint a few branches with Sable Brown in broken linework, following the original shapes.

tip *Tap off the excess paint on the palette to allow separation of the bristles.*

Norway Spruce

SHARON BUONONATO

MEDIUM: *Acrylic*

COLORS: *DecoArt Americana: Jade Green • Plantation Pine • Evergreen • Sable Brown Asphaltum • Raw Sienna • Black Plum • Yellow Ochre*

BRUSHES: *Sharon B's ³⁄₈-inch (10mm) blade • no. 4 round • no. 1 liner • ¹⁄₄-inch (6mm) angular*

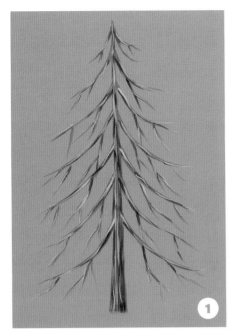
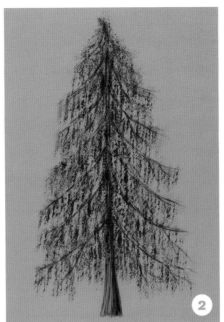
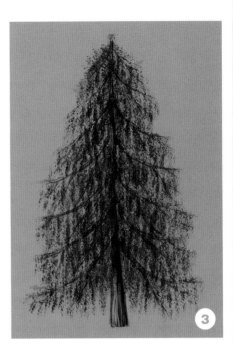
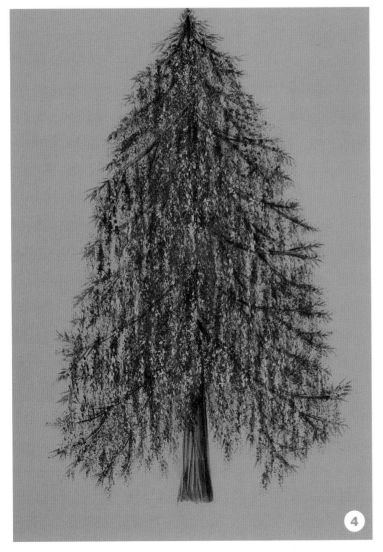

1 Base paint the trunk and branches using Sable Brown and the no. 4 round and the no. 1 liner. Shade the tree with Asphaltum linework, using the no. 1 liner. Highlight the same way, using Yellow Ochre.

2 Wash over the tree, using the round brush, with thin Raw Sienna to darken the trunk and branches. Float Black Plum on the right side of the tree trunk, using the ¼-inch (6mm) angular. Tap the needles onto the branches, using the chisel edge of the ⅜-inch blade (10mm) brush with Plantation Pine. The needles are painted vertically, dropping below each branch.

3 Using the same technique to paint the needles, add in Evergreen to fill out the tree. Do not lose the airy look of the branches and needles.

4 Add a few Jade Green needles to the center of the tree, using the chisel edge of the ⅜-inch (10mm) blade brush. Detail the tips of the branches with tiny Evergreen needles, using the no. 1 liner brush. Also repaint a few branches with Sable Brown in broken linework, following the original shapes.

tip *Tap off the excess paint on the palette to allow separation of the bristles.*

Lawson False Cypress

THEODORE C. TSE

MEDIUM: *Acrylic*

COLORS: *Hooker's Green Light* ◆ *Raw Umber* ◆ *Azo Yellow* ◆ *Titanium White*

MATERIALS: *natural sponge*

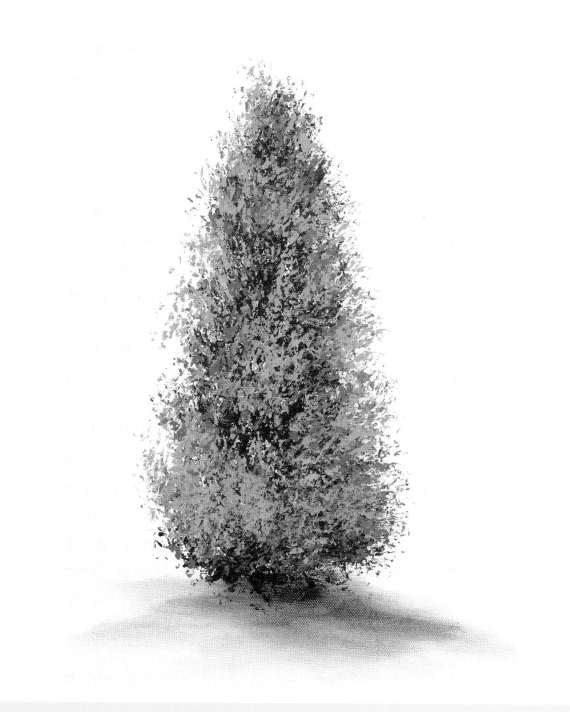

Colors

*Hooker's Green Light +
Raw Umber*

*Hooker's Green Light +
Azo Yellow + Raw Umber
+ Titanium White*

*Hooker's Green Light +
Azo Yellow + Raw Umber +
additional Titanium White*

*Hooker's Green Light +
additional Azo Yellow +
Raw Umber + Titanium White*

Lawson False Cypress CONTINUED

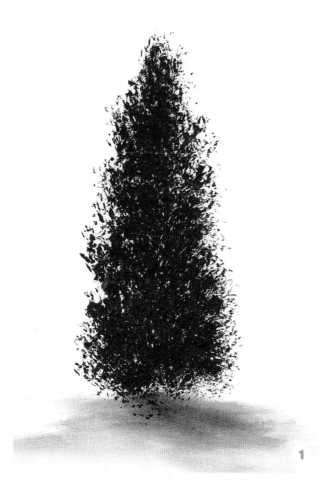

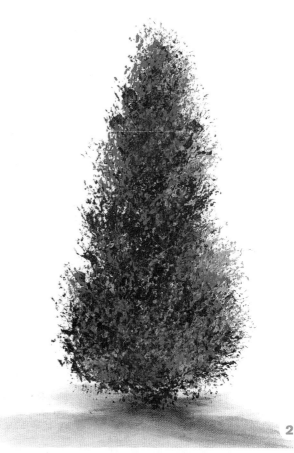

1 Use a natural sponge and dab with a mixture of Raw Umber and Hooker's Green Light to form a cone shape.

2 Add Azo Yellow and Titanium White to the first color and dab in here and there, making sure not to cover all of the first color.

3

4

3 Add more Titanium White to the color from step 2 and dab in where the lighted area will be.

4 Add a little more Azo Yellow to the color mixture and dab sparingly for sparkling highlights.

Cypress
SHARON BUONONATO

MEDIUM: *Acrylic*

COLORS: *DecoArt Americana: Jade Green ⋄ Plantation Pine ⋄ Evergreen ⋄ Yellow Ochre Sable Brown ⋄ Asphaltum ⋄ Black Plum ⋄ Raw Sienna*

BRUSHES: *Sharon B's ⅜-inch (10mm) blade ⋄ no. 4 round ⋄ no. 1 liner ⋄ ¼-inch (6mm) angular*

EVERGREENS

1 Paint the trunk and branches using Sable Brown and the no. 4 round and the no. 1 liner. Shade the tree with Asphaltum linework, using the no. 1 liner. Highlight the same way, using Yellow Ochre.

2 Wash over the tree, using the round brush, with thin Raw Sienna to darken the trunk and branches. Float Black Plum on the right side of the tree trunk, using the ¼-inch (6mm) angular. Using the chisel edge of the ⅜-inch (10mm) blade and Plantation Pine, start tapping on needles along both sides of the branches.

3 Using the chisel edge of the ⅜-inch (10mm) blade and Evergreen, continue tapping on needles along both sides of the branches, filling in the tree shape.

4 Highlight Jade Green in the center area of the tree, using the chisel edge of the ⅜-inch (10mm) blade in a diagonal pattern. If necessary, repaint a few branches with Sable Brown and Asphaltum broken linework, using the no. 1 liner.

Western Yellow Pine

THEODORE C. TSE

MEDIUM: *Acrylic*

COLORS: *Raw Sienna • Burnt Umber • Titanium White • Hooker's Green Light • Azo Yellow • Raw Umber*

BRUSH: *¾-inch (19mm) flat*

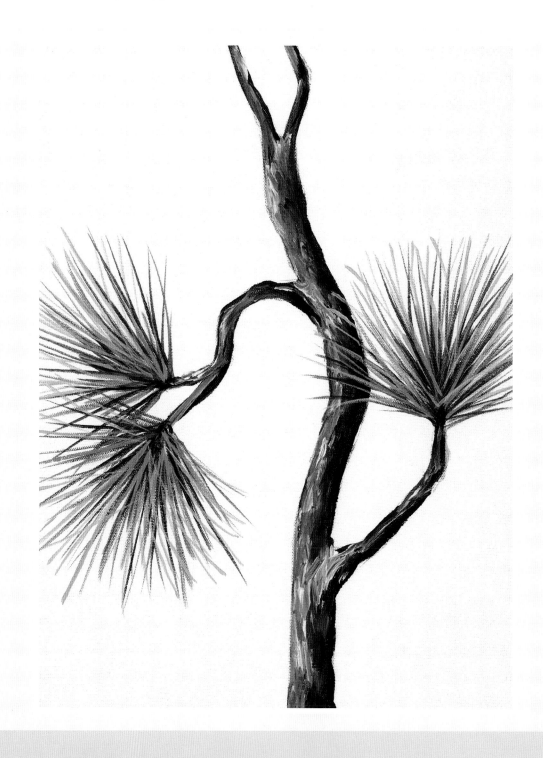

Colors

To paint a Western Yellow Pine, use the following colors:

Raw Sienna + Burnt Umber

Raw Umber

Raw Sienna

Titanium White

*Hooker's Green Light + Raw Sienna +
Raw Umber*

*Hooker's Green Light + Raw Sienna +
Raw Umber + Azo Yellow +
Titanium White*

*Hooker's Green Light + Raw Sienna +
Raw Umber + additional Azo Yellow +
additional Titanium White*

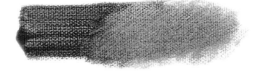
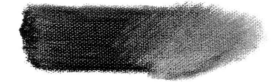
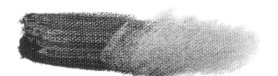

Western Yellow Pine CONTINUED

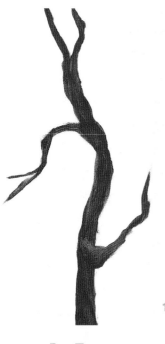

1 Paint the shape of the limb with a mixture of Raw Sienna and Burnt Umber. A ³/₄-inch (19mm) flat brush will work nicely.

2 Load the brush with Raw Umber and paint the shadow side of the limb.

3 Short, parallel strokes are applied along the limb with Raw Sienna, working wet-in-wet to the previous color.

4 The texture of the limb is created by using a ³/₄-inch (19mm) flat brush with the tip loaded with Titanium White. Apply Titanium White throughout the limb with short, parallel strokes, working wet-in-wet to the previous colors. For lighter areas, apply more Titanium White.

5 Use a ¾-inch (19mm) flat brush and paint pine needles with a mixture of Raw Umber, Hooker's Green Light and Raw Sienna. Start where the needles attach to the branch and paint outward.

6 Add Azo Yellow and Titanium White to the previous color and paint in more needles, over-lapping some of the darker greens.

7 To finish, mix more Azo Yellow and Titanium White in the step 6 color and paint additional needles, brushing inward.

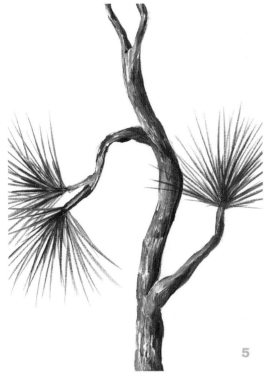

5

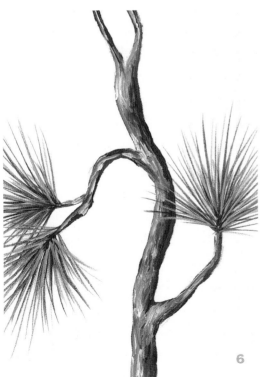

6

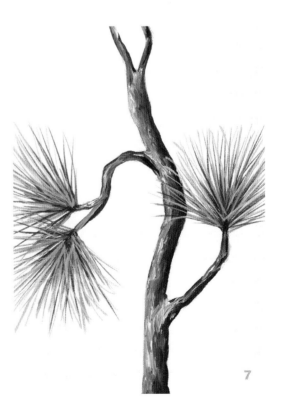

7

Summer Pine

LAURÉ PAILLEX

MEDIUM: *Acrylic*

COLORS: *White • Dark Green • Yellow Green • Yellow Ochre • Raw Sienna • Burnt Umber • Cobalt Blue*

BRUSHES: *angular bristle foliage • liner*

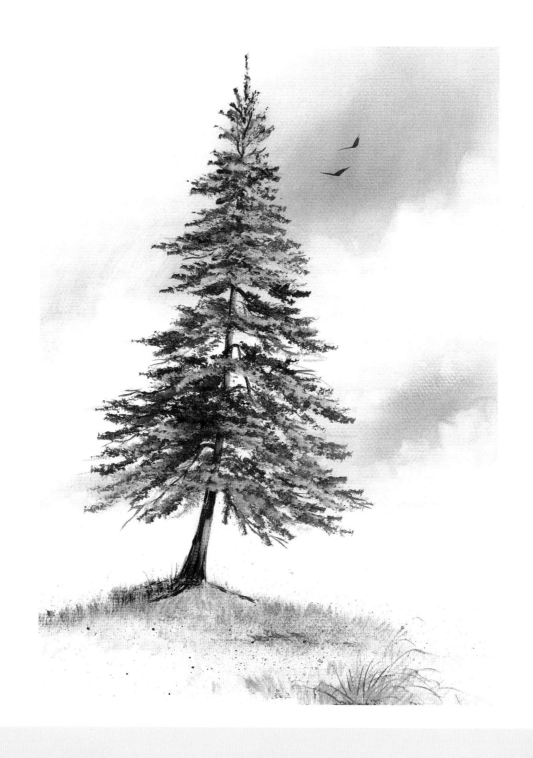

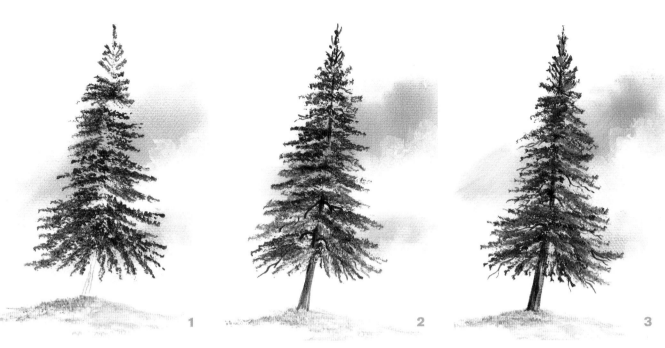

1

2

3

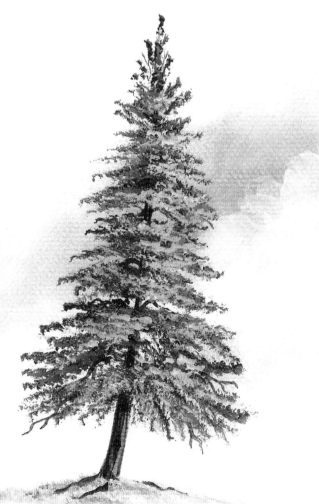

4

1 Lightly indicate trunk placement onto completed background. Place initial Dark Green branches, leaving open spaces for trunk sections.

2 Establish the trunk and main branches with light and dark brown hues.

3 Add the first highlight value with Yellow Ochre.

4 Strengthen highlights with Yellow Green, picking up a touch of White in the central highlight areas. Detail the trunk base with Burnt Umber. Add touches of Cobalt Blue in the shadowed areas.

CHAPTER 2
Shrubs

In this chapter, you'll find a variety of bushes and shrubs to paint. And you'll find special seasonal shrubs.

There are additional features such as detailed instruction for painting holly berries and foreground, midground and background bushes. All will help you add that extra touch to your art.

Holly & Berries

ELIZABETH HAYES

MEDIUM: *Oil*

COLORS: *Yellow Ochre Pale ◆ French Ultramarine ◆ Terra Rosa ◆ Cadmium Green Pale ◆ Ivory Black Cadmium Red Medium ◆ Cadmium Red Deep ◆ Titanium White ◆ Permanent Alizarin Crimson*

BRUSHES: *Royal Langnickel Series 1AT hog bristle filbert ◆ Royal Langnickel Series 5590 sables*

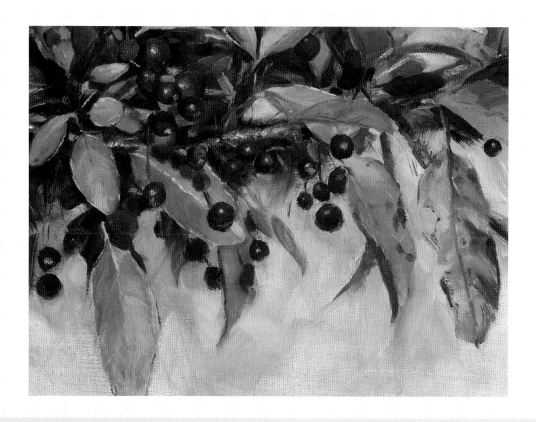

1 After washing the canvas with a thinned mixture of Yellow Ochre Pale and odorless turpentine, lay in the dark area with French Ultramarine and Terra Rosa and turpentine. Use a large brush for this step.

2 Using a soft rag, wipe out the predominate leaf and berry shapes.

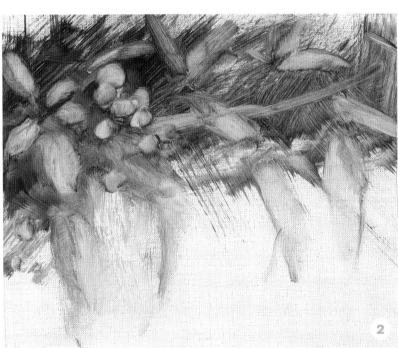

Holly & Berries

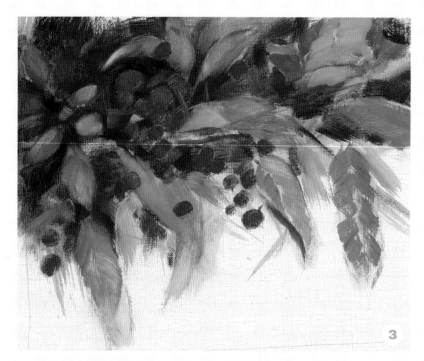

3 Using various mixtures of Cadmium Green Pale, Ivory Black and Yellow Ochre Pale, lay in the base tone of the leaves. Use Cadmium Red Deep for the berries. Darken areas in the background that are next to a light leaf that should be emphasized. Lighten the background using a gray mixture of Ivory Black and Titanium White for areas that need to be lightened. Establish the overall values and basic composition of the design. Don't get caught up in detail too soon.

4 Working carefully, concentrate on developing the detail in the focal point area, then softly add less defined leaves in the background. Paint the branch with Terra Rosa for the red area, Terra Rosa and French Ultramarine for the dark shadow areas and Ivory Black plus Titanium White for a grayish highlight.

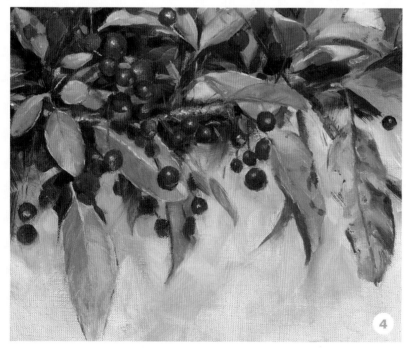

Leaf & Berry Detail

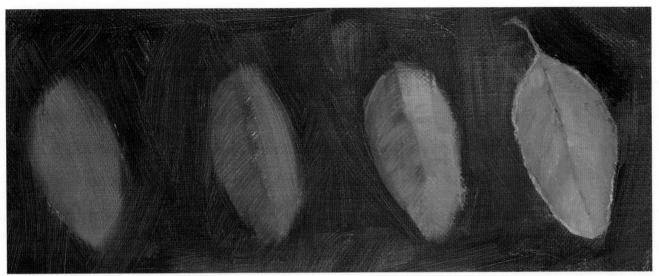

1 Lay in the overall value of the leaf using mixtures of Ivory Black, Yellow Ochre Pale and Cadmium Green Pale.

2 Darken one side by pulling brush hairs in the direction of leaf growth.

3 Lighten one side of the leaf.

4 Detail by suggesting veins and adding a light edge, using the chisel edge of the brush.

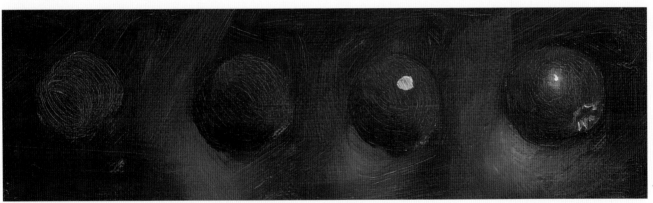

1 Lay in the overall value of the berry with Cadmium Red Medium.

2 Darken the shadow side with Permanent Alizarin Crimson and French Ultramarine.

3 Place a strong, pure Titanium White shine on the berry.

4 Soften out the shine and add the blossom end.

Winter Bushes

SHARON BUONONATO

MEDIUM: *Acrylic*

COLORS: *DecoArt Americana: Jade Green ◆ Plantation Pine ◆ Evergreen ◆ Sable Brown
Asphaltum ◆ Plum ◆ Soft Black ◆ Hi-Lite Flesh*

BRUSHES: *Sharon B's no. 6 halo ◆ Sharon B's ³/₈-inch (10mm) blade ◆ no. 1 liner*

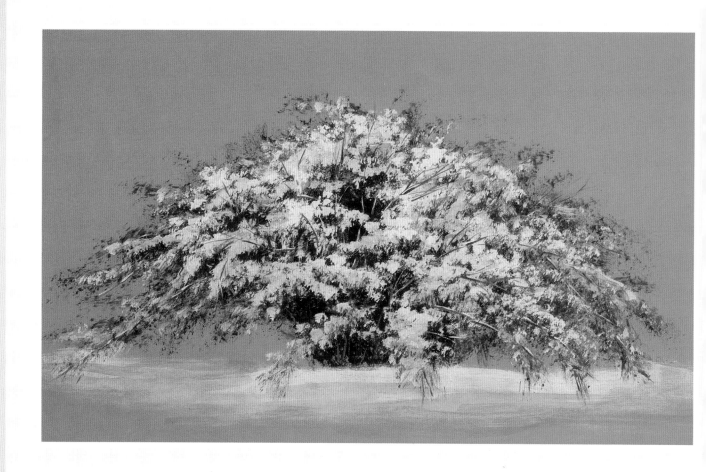

1 To properly load the halo brush, draw a line of paint on the palette and tap across it. Load the brush halfway around, starting at the top of the angle chisel edge. Form a fountain-shaped bush by tapping on Soft Black, allowing the curve of the halo to paint the drooping branches. The branches get shorter as they reach the top of the bush.

2 Add Evergreen branches, as in step 1, to fill in the fountain shape. Paint the branches to extend further out and down at the base.

Winter Bushes CONTINUED

3 Detail the bush with Sable Brown and Asphaltum broken linework along several of the branches and the vertical base using the no. 1 liner. Repeat the halo brush procedure using Plantation Pine extending out to enlarge the bush, leaving the center dark. Paint a few Jade Green highlights the same way on the center of the bush.

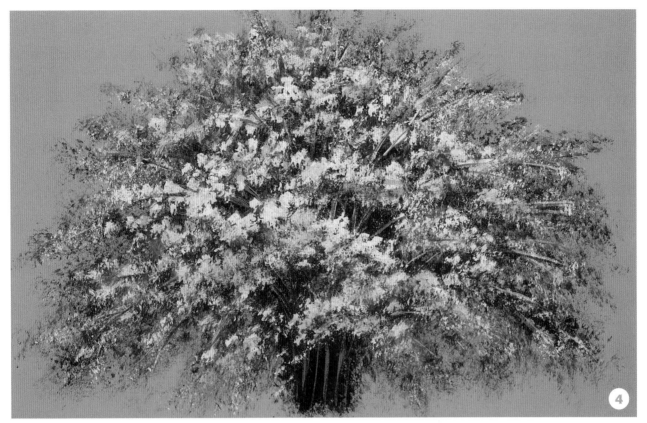

4

4 Apply snow, using the tip of the ³/₈-inch (10mm) blade and Hi-Lite Flesh by dabbing small clumps on the center of the bush. With the remaining paint on the brush, tap delicate snow on the outer branches. Tint here and there with very thin Plum on the snow clumps to cool. Place snow along a few of the brown branches with Hi-Lite Flesh linework.

Forsythia Bush

SHARON BUONONATO

MEDIUM: *Acrylic*

COLORS: *DecoArt Americana: Jade Green ◆ Plantation Pine ◆ Evergreen ◆ Sable Brown*
Asphaltum ◆ Raw Sienna ◆ Bright Yellow ◆ Cadmium Yellow ◆ Yellow Ochre

BRUSHES: *Sharon B's no. 6 halo ◆ no. 1 liner*

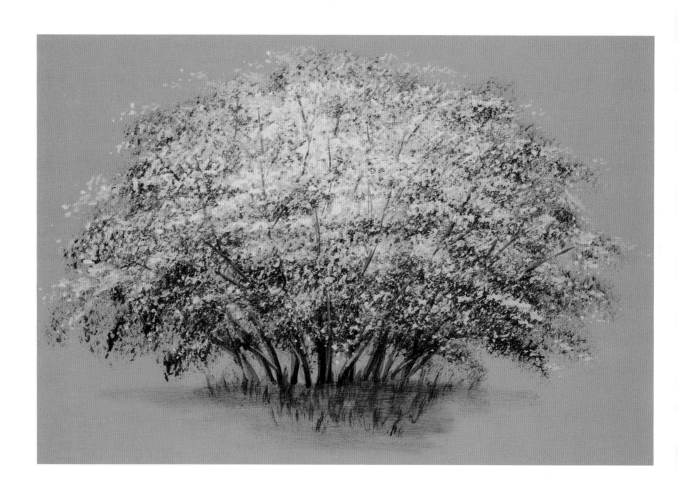

1 Paint the branches Sable Brown, using the no. 1 liner. Shade the branches with Asphaltum linework and highlight the same way with Yellow Ochre. To properly load the halo brush, first draw a line of paint on the palette and tap across it. Load the brush halfway around, starting at the top of the angle chisel edge. Form curved leaves by tapping Plantation Pine horizontally across the branches.

2 Wash over the branches with thin Raw Sienna, using the no. 1 liner. Add more leaves, following the same procedure as step 1, using Evergreen.

tip *This bush has an open-umbrella shape formed by using the halo brush.*

Forsythia Bush CONTINUED

3 Following the same painting technique and using the halo brush, add Jade Green leaves, staying more to the center and top of the bush.

4 Follow the same technique using the halo brush, and paint Bright Yellow (yellow-green) leaves on the top and center areas of the bushes. A few yellow leaves are sprinkled in with the bottom green leaves. Paint a liberal amount of Cadmium Yellow over the previous colors in the same way, but do not lose the greens. Finish with delicate Sable Brown and Asphaltum broken linework, following the original direction of the branches with the no. 1 liner.

Summer & Autumn Spike Bushes

SHARON BUONONATO

MEDIUM: *Acrylic*

COLORS: *DecoArt Americana: Jade Green • Plantation Pine • Evergreen • Black Plum • Pumpkin Cadmium Red • Deep Burgundy • Yellow Ochre*

BRUSHES: *Sharon B's ³⁄₈-inch (10mm) blade • no. 1 liner*

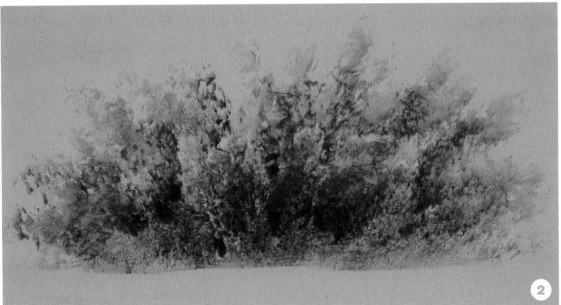

1 To triple load the chisel edge of the blade brush, tap Plantation Pine across the chisel edge. Then load the tip with Jade Green by poking into the edge of the paint puddle. Next load the low corner with Evergreen in the same way. Tap on the palette to lightly blend and separate the bristles. Tap on a fan-shaped bush by starting in the center and then tapping to either side.

2 Distant & Background Bush: To paint a distant bush, first dampen the surface with clean water. Then proceed with the same technique as shown in step 1. To paint a larger background bush, add a second row to the bottom of the bush on a dry surface. Keep the lighter color to the top when tapping on the application.

Summer & Autumn Bushes CONTINUED

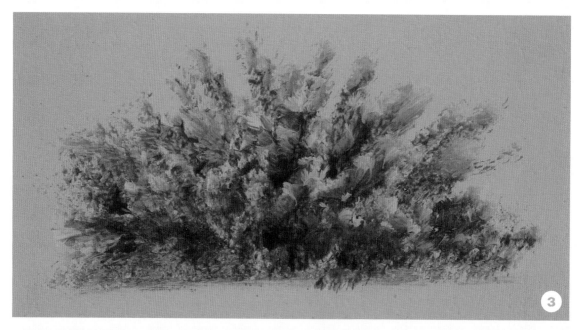

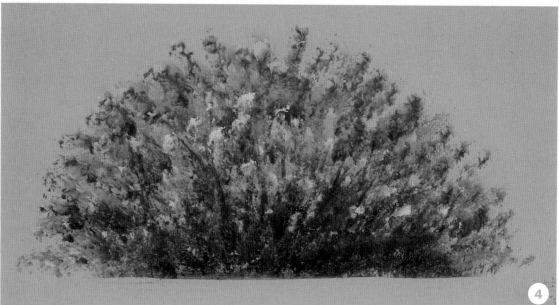

3 Midground Bush: A midground bush will require a third row painted the same way on a dry surface.

4 Foreground Bush: A foreground bush will have five or six rows of triple loading the blade brush to fluff out and enlarge. Add Yellow Ochre highlights to the center by triple loading the blade brush, substituting Yellow Ochre for the Jade Green. Paint a few Black Plum branches at the base of the bush, using the no. 1 liner.

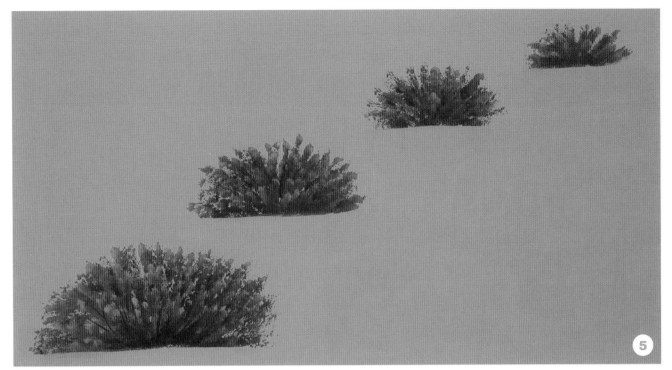

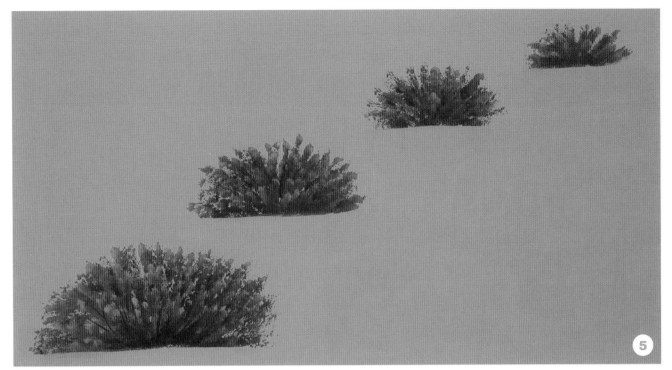 appears with the circled number 5 in its lower-right corner.

5 Autumn Bush: The Autumn bush is painted the same way, substituting Pumpkin, Cadmium Red and Deep Burgundy. There is no need for yellow highlights on the foreground bush, but there are Black Plum branches painted at the base. Mixing the two different colored bushes together creates a late summer/early Autumn composition.

Spreading Bushes
SHARON BUONONATO

MEDIUM: *Acrylic*

COLORS: *DecoArt Americana: Jade Green ◆ Plantation Pine ◆ Evergreen ◆ Yellow Ochre*
Sable Brown ◆ Asphaltum

BRUSHES: *Sharon B's no. 6 halo ◆ no. 1 liner ◆ 1-inch (25mm) flat*

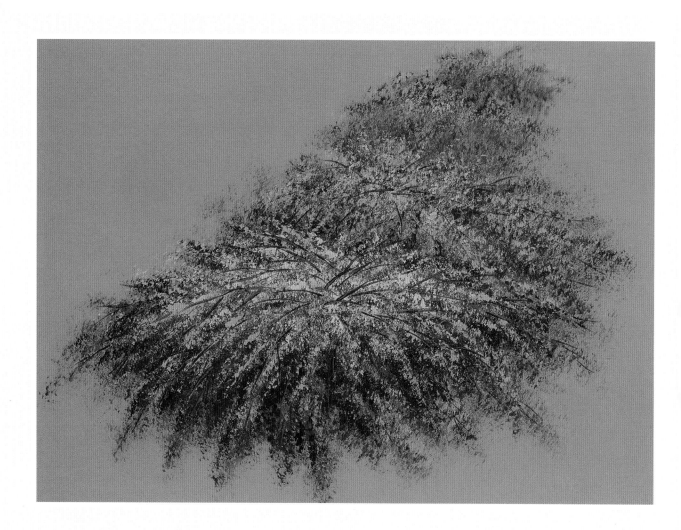

1 To properly load the halo brush, draw a line of paint on the palette and tap across it. Load the brush halfway around, starting at the top of the angle chisel edge. Form a flattened bush with "legs" spreading out in all directions by tapping on Plantation Pine. Follow this application with Evergreen done the same way. Both greens should be visible and very delicate and airy. The third application is Jade Green placed to the top and center areas.

2 Distant & Background Bush: To make the bush appear more distant, first apply clean water with the 1-inch (25mm) flat, then paint as directed. As the bushes come forward in a composition, they become background bushes. Repeat the same technique as step 1, adding more "legs" and painting slightly larger on a dry surface.

3 Midground Bush: To paint a larger midground bush, load more paint onto the chisel edge of the halo by going three-quarters of the way around. This will provide more coverage and maintain the same airy look as in step 2.

4 Foreground Bush: Simply repeat the same loading technique and procedure as directed in step 3, enlarging the shape. Paint Yellow Ochre highlights on the center top of the bush in the same way. To complete the foreground bush, add a few Sable Brown and Asphaltum linework branches along several of the "legs" using the no. 1 liner. Also add a few branches sticking out of the top and center in the same way.

CHAPTER 3
Leaves

This chapter will show you how to paint leaves. There are several projects for all painting levels.

You'll also find a number of basic and special leaves in a variety of mediums. All will add the finishing touches to your artwork.

Basic Leaves

KERRY TROUT

MEDIUM: *Acrylic*

COLORS: *DecoArt Americana: Hauser Light Green ⬩ Avocado ⬩ Light Avocado ⬩ Titanium White Evergreen ⬩ Burnt Sienna*

BRUSHES: *no. 6 flat shader ⬩ no. 12 flat ⬩ no. 2 script liner*

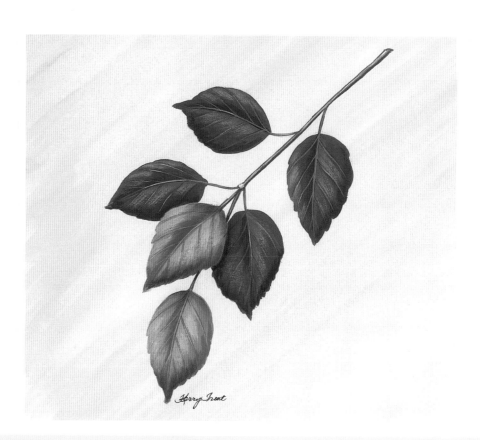

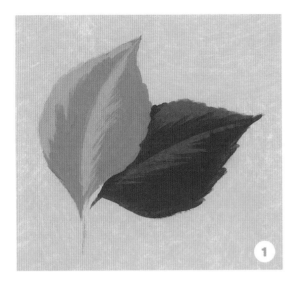

1 Use a no. 6 flat to basecoat light leaves with Hauser Light Green. Basecoat darker leaves with Avocado. Highlight the light leaves with Titanium White and Hauser Light Green (1:1). Use an angled dry-brush stroke and apply the highlight according to your light source—on the outer edge and against the center vein.

2 Shade the light leaves with Light Avocado and the dark leaves with Evergreen. Using the same brush, apply these colors on the opposite of where you applied the highlights.

3 Use a no. 2 script liner and thinned Avocado to apply veins on the light leaf. Always stroke from the center outward. For the dark leaf, use a 1:1 mix of Avocado and Evergreen.

4 Go over veins lightly (on the light leaf) with a 1:1 mix of Light Avocado and Titanium White, and a 1:1 mix of Avocado and Titanium White for the dark leaf. Float Evergreen with a no. 12 flat around the base of the light leaf and float it against any edge of a leaf that is overlapping another. Float Burnt Sienna randomly on edges and tips of either leaf. Drybrush Hauser Light Green and Titanium White (1:2) across the lightest areas between the veins.

tip *Make leaves two-toned. Smaller, younger leaves should be lighter than others.*

Northern Red Oak Leaf

BONNIE FREDERICO

MEDIUM: *Watercolor*

COLORS: *Burnt Umber • Winsor Red • Burnt Sienna • Alizarin Crimson • dark green*

BRUSHES: *no. 8 round • no. 4 round*

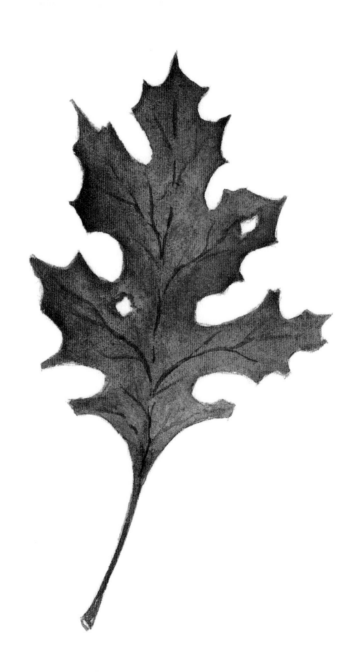

1 Using a no. 8 round brush, dampen the leaf shape area with clean water, being very careful with your placement. When the leaf is evenly damp and has a sheen to it, apply an even wash of Burnt Umber and Winsor Red. Be careful to outline the points and fill in the center area. Let dry.

2 Re-dampen the leaf with clean water. Apply Burnt Umber on the edges and the Burnt Umber and Winsor Red mix to reinforce the base color. A dark green can be introduced at the base of the leaf for interest. Let dry.

3 Using a no. 4 round brush, add veins in Burnt Umber and detail around the bite holes. Drybrush a dark green, Burnt Sienna and Alizarin Crimson to make the oak leaf more interesting. Every leaf is different.

1

2

3

LEAVES

Standard Leaf

NANCY DALE KINNEY

MEDIUM: *Acrylic*

COLORS: *DecoArt Americana: Antique Green* ◆ *Black Green* ◆ *Celery Green* ◆ *Victorian Blue*

BRUSHES: *Nancy Kinney's small dabber* ◆ *Loew-Cornell: no. 6 flat chisel blender* ◆ *½-inch (13mm) wash*

OTHER SUPPLIES: *Jo Sonja's Retarder and Antiquing Medium*

1 Using the no. 6 flat, basecoat the leaf and stems with two coats of Antique Green. Let dry.

2 With the ¹/₂-inch (13mm) wash, dampen the leaf with retarder. Use the small dabber and begin to darken in the areas shown with Black Green. Wipe the brush on a paper towel and dab or lightly rub to blend. Wipe brush often.

3 Dampen with retarder. Using the dabber, paint in Celery Green in the light areas of the leaf. Wipe brush and softly blend where Antique Green and Celery Green meet. Wipe brush often while blending. Let dry.

4 Dampen and further build up depth in your leaf by repeating the previous steps. Add an accent value to add interest to the leaf. This color will vary according to your design. Here, a touch of Victorian Blue was used. Be sure to paint the Victorian Blue on the medium value, which is Antique Green.

Leaves for Beginners

SANDY AUBUCHON

MEDIUM: *Acrylic*

COLORS: *DecoArt Americana: Light Avocado ◆ Plantation Pine ◆ Asphaltum ◆ Titanium White
Jade Green ◆ Avocado ◆ Alizarin Crimson ◆ Raw Sienna*

BRUSHES: *no. 8 flat ◆ no. 0 script liner*

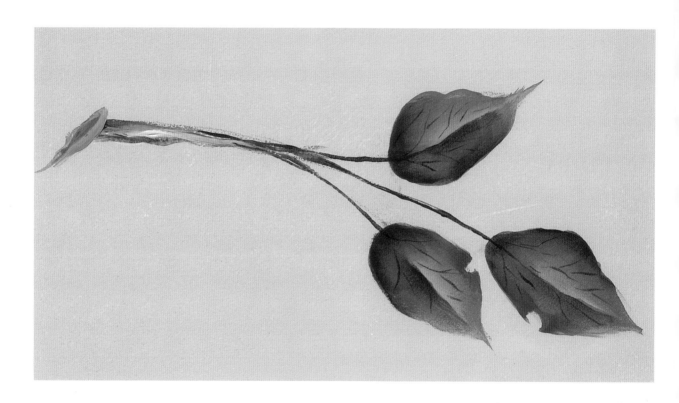

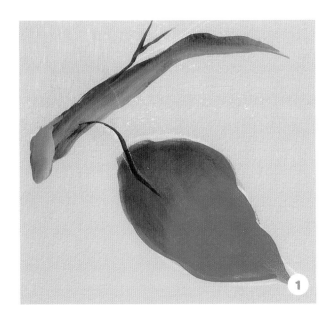

1 Basecoat the leaf using a no. 8 flat and Light Avocado. When dry, float Plantation Pine for the shadow area. The branch is Asphaltum plus Titanium White.

2 Shade just to one side of the vein area with the same brush.

3 Highlight with a float of Jade Green, using a pivot stroke.

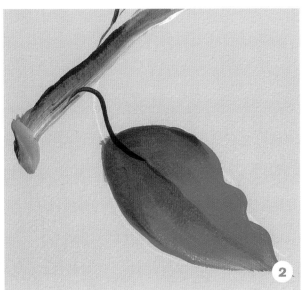

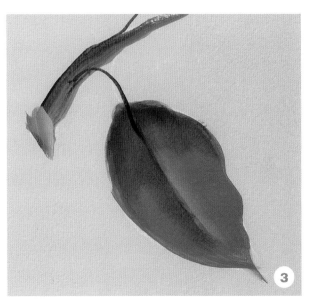

Leaves for Beginners

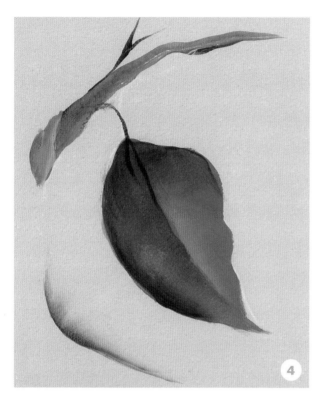

4 Burnish the leaf with a float of Asphaltum down one edge.

5 Establish a bug bite with Avocado.

6 Float Alizarin Crimson and Raw Sienna together on one corner of the brush.

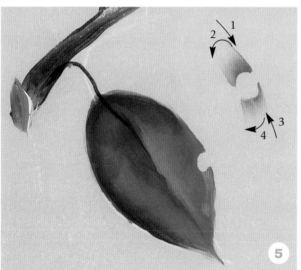

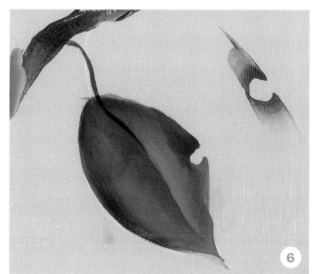

LEAVES

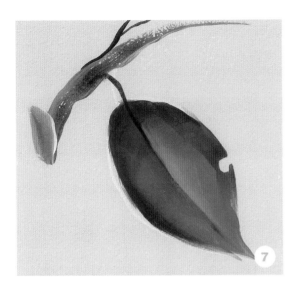

7 Apply the second area of the bug bite.

8 Finish by painting the vein details using a no. 0 script liner with water and Asphaltum.

Holly Leaf & Berries

NANCY DALE KINNEY

MEDIUM: *Acrylic*

COLORS: *DecoArt Americana: Black Green ◆ Black Plum ◆ Celery Green ◆ Deep Burgundy Hauser Medium Green ◆ Light Buttermilk ◆ True Ochre ◆ True Red*

BRUSHES: *Nancy Kinney's small dabber ◆ Loew-Cornell: no. 4 flat chisel blender ◆ no. 6 flat chisel blender no. 1 liner ◆ ½-inch (13mm) wash*

OTHER SUPPLIES: *Jo Sonja's Retarder and Antiquing Medium*

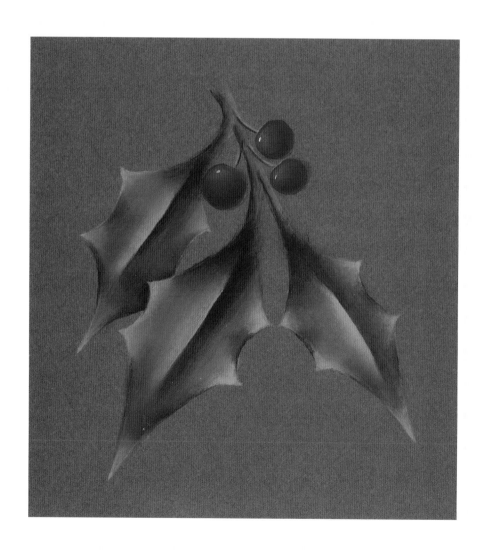

1 Using the no. 6 flat, basecoat the leaves and stems with two coats of Hauser Medium Green. Use the no. 4 flat to basecoat the berries with two coats of Deep Burgundy. Let dry.

2 With the ½-inch (13mm) wash, dampen a leaf with retarder. Using the small dabber, begin to darken selected areas, as you see in the photo, with Black Green. Always begin with the leaf that is under all of the others. Darken down each stem with the liner and a touch of Black Green.

3 Wipe brush on a soft paper towel and dab or lightly rub to blend where the Hauser Medium Green and the Black Green meet. Dry, dampen and repeat steps 2 and 3 to further build depth. Let dry.

4 Dampen with retarder. Using the dabber, paint in Celery Green in the light areas of the leaf. Wipe brush and softly blend where Hauser Medium Green and Celery Green meet. Wipe brush often while blending.

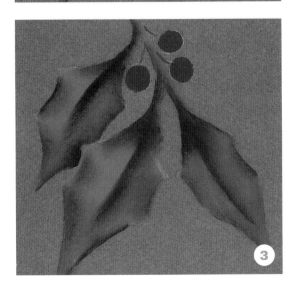

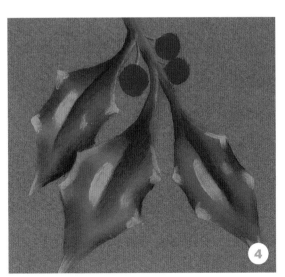

Holly Leaf & Berries

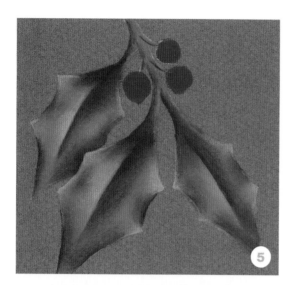

5 Wipe brush on a paper towel and dab or lightly rub the Celery Green to blend. Let dry and repeat to build more depth.

6 Using the liner, add the tiny tips to each point with a touch of True Ochre. Lightly pull the back edge into the leaf to soften the edge. Add a touch of Deep Burgundy to the medium value, which is Hauser Medium Green, to add a reflection from the berries.

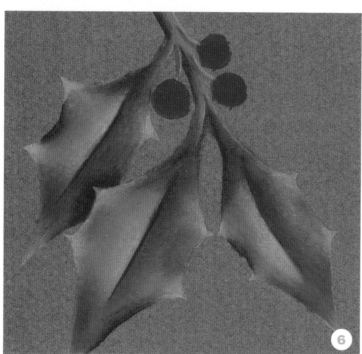

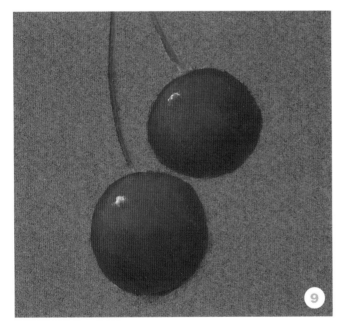

7 Dampen the berry with retarder. Use the dabber to paint in the crescent-shaped dark value using Black Plum. Wipe the brush and lightly dab to blend. Using the liner, paint Black Plum down the left edge of each stem. Let dry.

8 Again dampen the berry with retarder and dab in True Red in the same areas. Further lighten with just a tiny touch of True Ochre while the True Red is still wet.

9 Once again, dampen the berry with retarder and dab in True Red in the same areas. Further lighten with just a tiny touch of True Ochre while the True Red is still wet. Add a sparkle of Light Buttermilk in the upper left corner.

LEAVES

Grape Vine Leaves

TERENCE L. TSE

MEDIUM: *Acrylic*

COLORS: *Raw Umber ♦ Hooker's Green Light ♦ Magenta ♦ Titanium White*
Azo Yellow ♦ Yellow Ochre ♦ Raw Sienna ♦ Thalo Blue

BRUSHES: *liner ♦ 1-inch (25mm) flat ♦ small round*

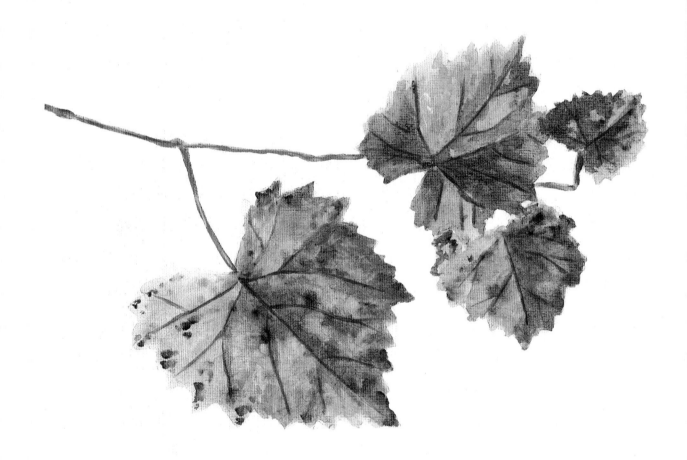

Colors

TO PAINT GRAPE VINE LEAVES, USE THE FOLLOWING COLORS:

Titanium White + Azo Yellow +
Yellow Ochre + Raw Umber

Titanium White +
Hooker's Green Light + Raw Umber

Hooker's Green Light + Raw Umber

Titanium White + Magenta
+ Raw Umber

Magenta + Raw Umber

Raw Sienna

LEAVES

75

Grape Vine Leaves CONTINUED

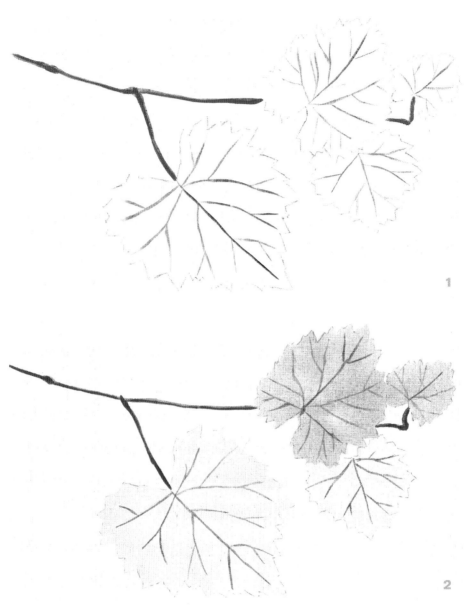

1

2

1 Lightly pencil in the leaf design. To retain detail, outline leaves and stem with a mixture of Raw Umber and Hooker's Green Light using a liner brush. Highlight stem with a mixture of Raw Umber, Magenta and Titanium White.

2 Block in leaves with a 1-inch (25mm) flat. The yellow leaves are a combination of Azo Yellow, Yellow Ochre and Raw Umber. Titanium White, Hooker's Green Light and Raw Umber make the green wash.

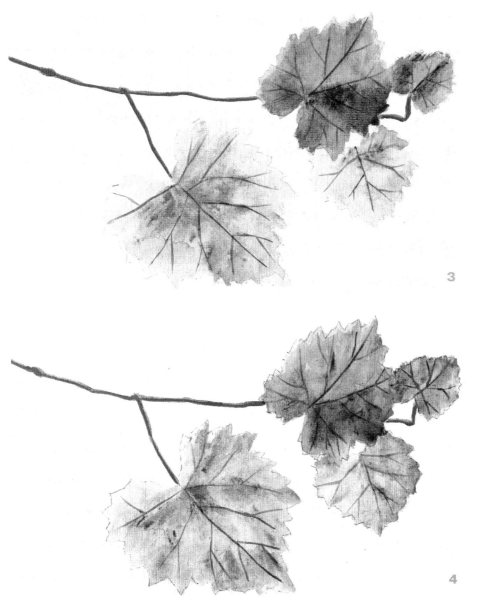

3

4

3 Using a 1-inch (25mm) flat, apply clear water to the leaves. With a combination of Raw Umber, Hooker's Green Light and a little Titanium White, dab colors into the leaves and allow the colors to diffuse.

4 With the same water-diffused color technique used in step 3, "charge" Raw Sienna over areas of the leaves.

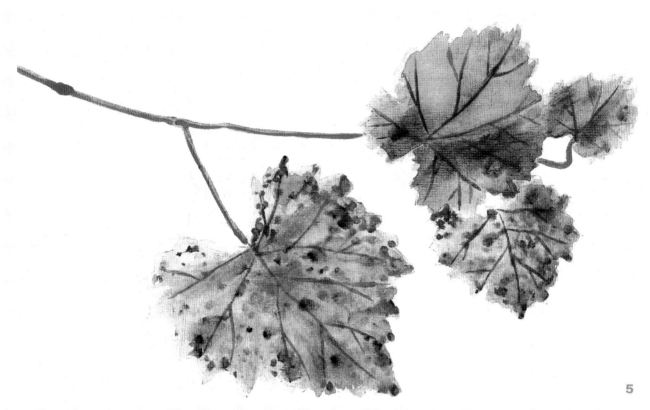

5

5 Apply clear water on the leaves again, as in step 3. Use a mix of Raw Umber and Magenta on a small, round brush and dot over the leaves.

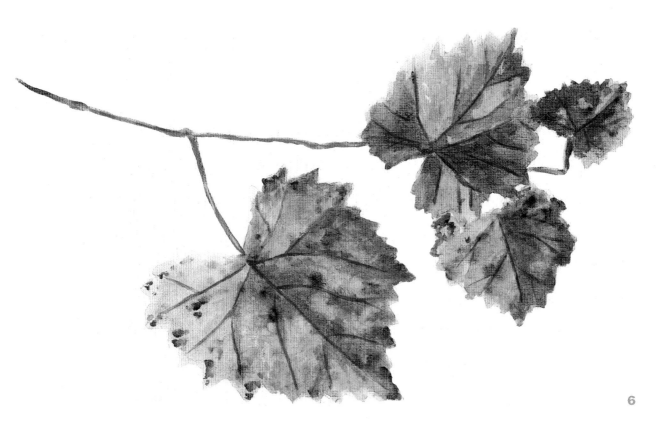

6

6 Use Raw Umber with a little Thalo Blue for shadow areas. Highlight leaves and stem with Titanium White and a little Raw Umber.

Painting Foliage with an Angular Bristle Brush

LAURÉ PAILLEX

BRUSH DESCRIPTION

Angular bristle brushes, also called "foliage brushes," are made of natural white China boar bristles and are specially designed for creating a vast array of textural effects. They come in a variety of sizes ranging from ¼-inch (6mm) to 1-inch (25mm) in width.

When choosing an angular bristle brush, look for a brush with a full volume of tapered hairs set deep into the ferrule on an even slant. The base of the metal ferrule should be firmly attached to a well-balanced handle. A good quality brush will retain its shape even after hard use on canvas, wood or other rough surfaces.

LOADING THE BRUSH

Before you begin painting with acrylics, soak the brush in clean water for a minute, allowing the natural bristles to soften as they absorb moisture. When using oil media, moisten the brush with clean painting medium. Blot the brush well to remove excess moisture before loading with paint.

The brush, when viewed from its flat side, resembles a foot—the long bristles represent the "toe" and the short bristles represent the "heel". Applying slightly heavier pressure to the heel will fill in an area more completely, while a lighter pressure on the toe results in a more open, lacy effect. Use the entire width of the brush and take advantage of the angular slant to achieve the desired results.

Double Load

Load on Toe

DOUBLE LOAD

The color placement on the brush will be determined by the final effect you wish to achieve in your painting. Generally, colors are loaded with the darker (shading) value on the short hairs of the brush and the lighter value on the long hairs. Work the brush back and forth on your palette until a gradual transition of color is achieved. Initially, you may have to reload the brush several times until enough paint fills the brush. Double loading is useful for establishing patterns of light and shadow where a gradual transition of color is desired, such as in the first "under painting" stage of a landscape or when creating layers of foliage on shrubs or deciduous trees.

HALF LOAD ON THE TOE

Using a clean, pre-moistened brush, load only the longer bristles to fill about one-third to one-half of the width of the brush. Pat or splay the brush on your palette depending on the desired effect. Place the entire width of the slant against the painting surface allowing the paint-filled bristles to deposit the color. This technique is especially useful for accenting highlights and building up textured areas.

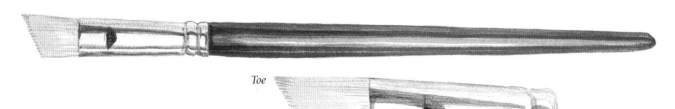

Toe

Heel

Ferrule

Load on Heel

HALF LOAD ON THE HEEL

Using a clean brush, load only the short bristles on the heel to fill the brush part way up the slant. Work the brush on your palette to distribute the paint into the brush. Place the brush against your painting surface, heel down first, wherever a subtle filled-in look is desired such as in shadows or at the base of trees or shrubs.

BRUSH CONTROL

Rinse the brush often as you work, wiping it back and forth into its flat shape on a towel before reloading with paint. Do not allow paint to work its way up into the metal ferrule.

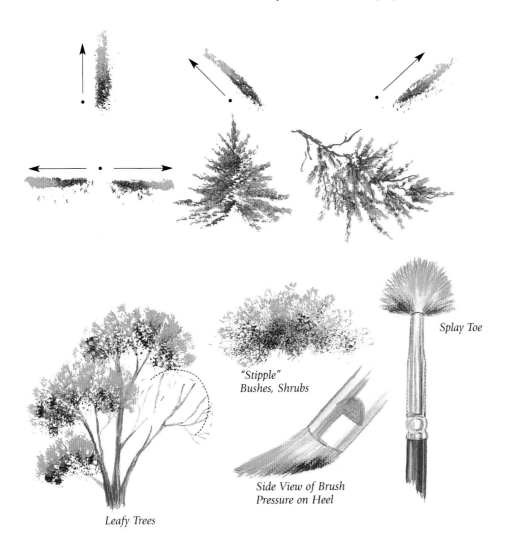

Splay Toe

"Stipple"
Bushes, Shrubs

Side View of Brush
Pressure on Heel

Leafy Trees

SPLAYED BRISTLES

For open, lacy foliage or textured accents, splay the long bristles out on the palette while applying pressure to the heel of the brush. If desired, pick up additional paint on the open toe bristles before applying to the painting surface.

KNIFE EDGE

For a controlled application, such as for the tops of evergreen trees or for drybrushing, flatten the bristles together into a tight knife edge. Remember to place the full width of the brush against your painting surface.

Deciduous Trees

Trees—with and without leaves—are featured in this chapter. There are demos of a wide assortment of trees. And there is a guide that features tree silhouettes for five tree varieties.

There are even a few examples of how to paint certain types of tree bark. All will help you think—and paint—more creatively.

White Birch Bark

LAURÉ PAILLEX

MEDIUM: *Acrylic*

COLORS: *White • Burnt Umber • Black*

BRUSHES: *flats • liner*

OTHER SUPPLIES: *DecoArt Weathered Wood Crackle Medium*

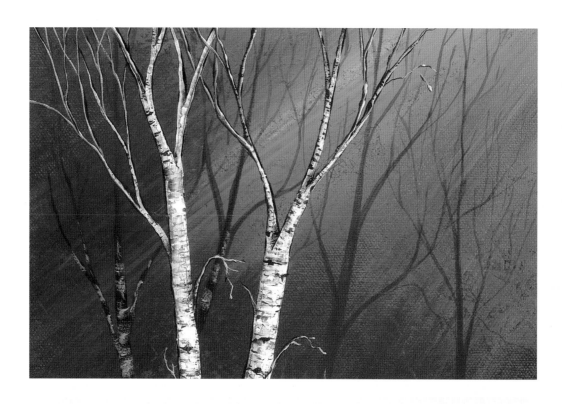

1 Basecoat trunk and large branches with a Burnt Umber + Black mix. Let dry. Apply crackle medium to basecoated areas. Let dry.

2 Lay a thick, generous layer of undiluted White on top of prepared trunk and branches. Do not disturb topcoat once it has been placed. Let dry.

3 Float-shade the edges and place random details with a thin Burnt Umber + Black wash.

4 Strengthen shadows with additional color washes. Embellish bark cracks and add fine details with a dark Black + Burnt Umber mix.

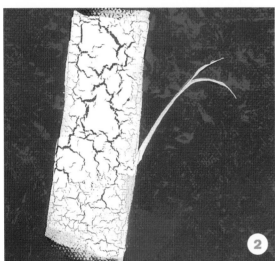

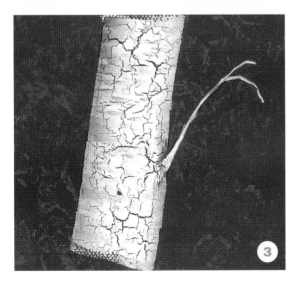

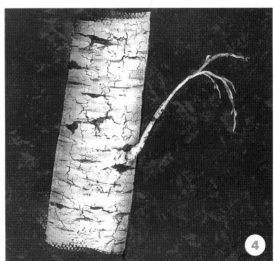

Deciduous/Hardwood Tree

GREG ALBERT

MEDIUM: *Oil*

COLORS: *Burnt Umber • Organ Green • Yellow Ochre • Viridian • Sap Green • Ultramarine Blue • White*

BRUSHES: *small round • medium filbert*

OTHER SUPPLIES: *solvent (turpentine, odorless paint thinner, etc.)*

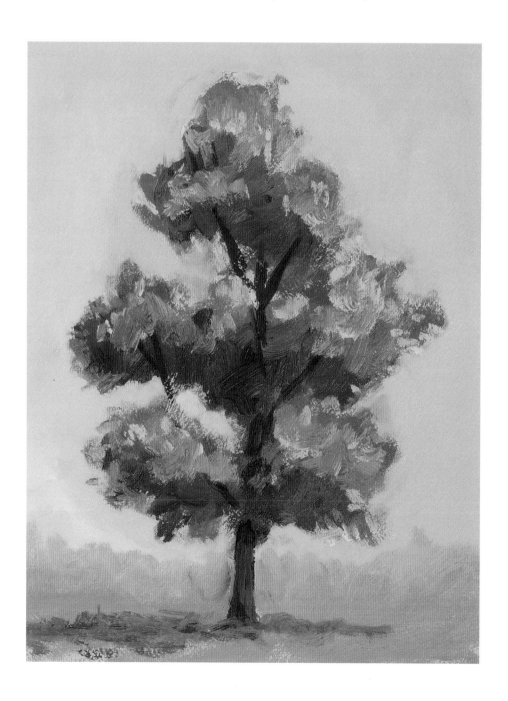

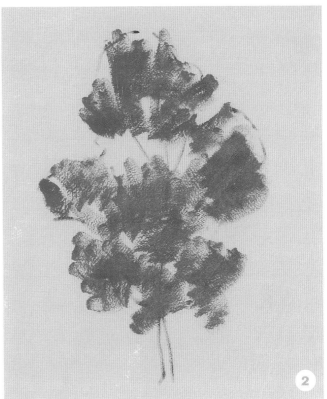

1 Using a small, round brush and a thin mixture of Burnt Umber and solvent, draw the outline of the shapes lightly.

2 Block in the large masses of foliage in a mid-tone Organ Green color using a medium-sized filbert brush (flats make undesirable square-shaped strokes). In the example, Yellow Ochre, Viridian and Sap Green were used.

Deciduous/Hardwood Tree CONTINUED

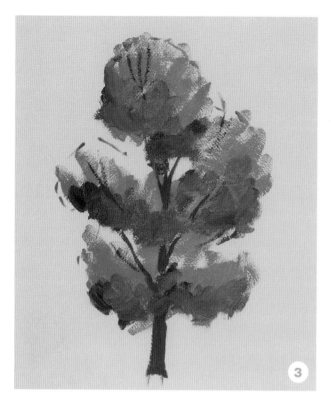

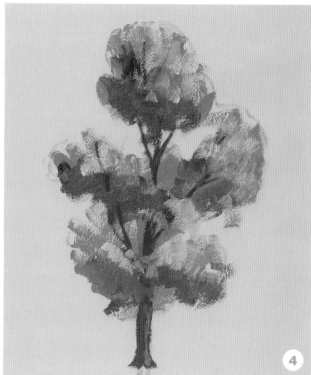

3 Using the same brush, block in the darker shadows on the lower parts of the foliage masses. Viridian, Sap Green and Burnt Umber were used. Don't overblend. Paint the tree trunk with a dark brown-gray; Burnt Umber and Ultramarine Blue with a little White make a nice bark color. Tree trunks are rarely pure brown. Indicate branches within the mass of leaves.

4 Paint in the lighter values where the masses of leaves are in sunlight. Be consistent with the direction of the light. Don't overblend—you are suggesting the leafy texture of the foliage, not every single leaf. Paint the side of the trunk in the light with brown, blue and more white.

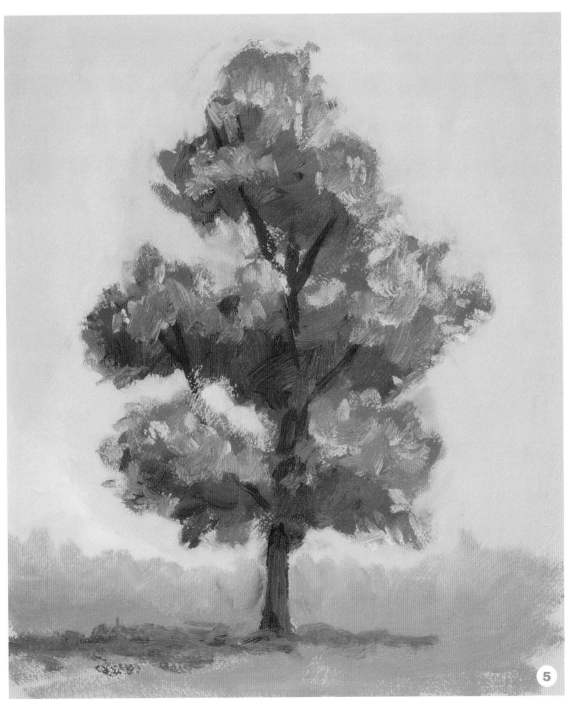

5 The finished tree. Remember to paint a shadow under the tree opposite the light source. Leave "sky holes" in the foliage showing the blue sky behind the tree. Trees are rarely hard-edged, solid shapes of green.

Tree Without Foliage

NANCY DALE KINNEY

MEDIUM: *Acrylic*

COLORS: *DecoArt Americana: Light Buttermilk ◆ Fawn ◆ Asphaltum*

BRUSHES: *Nancy Kinney's small dabber ◆ Loew-Cornell: no. 1 liner ◆ ½-inch (13mm) wash*

OTHER SUPPLIES: *Jo Sonja's Retarder and Antiquing Medium*

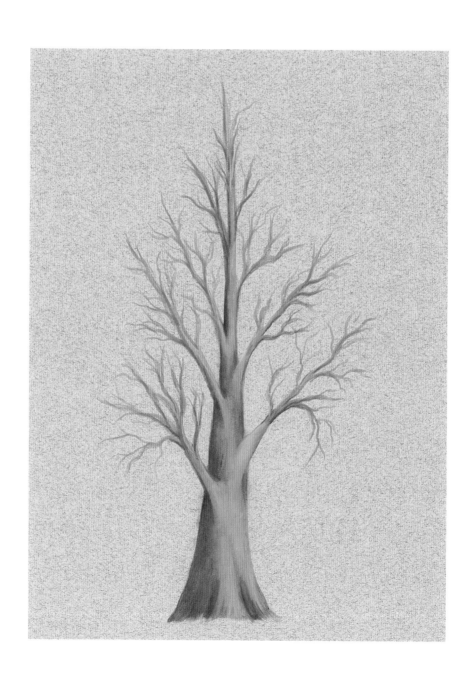

1 Base in the bare tree with two coats of Fawn. Let dry.

2 With the no. 1 liner and a brush mix of Fawn + Asphaltum, continue painting tiny limbs. Pull from the larger branches. Lightly blend where the limb color meets the branch color. Let dry.

3 Use the ½-inch (13mm) wash to dampen the tree with retarder. Then use the chisel edge of the small dabber and begin to darken the left side of the tree with Asphaltum. Darken above and below where the branches meet the tree. Use the liner with thinned Asphaltum to paint in the details indicating bark and giving the smaller branches more detail. Let dry. If needed, dampen and repeat this step for more depth.

4 Dampen with retarder and begin to lighten the middle of the tree and along the top edges of the branches with a brush mix of Fawn + Light Buttermilk.

TREES

Live Oak & Spanish Moss

SHARON BUONONATO

MEDIUM: *Acrylic*

COLORS: *DecoArt Americana: Jade Green ◆ Plantation Pine ◆ Evergreen ◆ Yellow Ochre*
Sable Brown ◆ Asphaltum ◆ Black Plum ◆ Raw Sienna ◆ Soft Black ◆ Soft Blue

BRUSHES: *Sharon B's ³⁄₈-inch (10mm) blade ◆ Sharon B's no. 8 trident ◆ no. 1 liner*
no. 4 round ◆ ¹⁄₄-inch (6mm) angular

TREES

90

1 Paint the trunk and branches with Sable Brown and the no. 4 round and the no. 1 liner brushes. Shade the tree with Asphaltum and Soft Black linework, using the no. 1 liner. Highlight the same way, using Yellow Ochre. Tap Plantation Pine on leaves, using the chisel edge of the no. 8 trident brush. This will leave a triangular leaf pattern allowing for plenty of "sky holes."

2 Wash over the tree, using the round brushes, with thin Raw Sienna to darken the trunks and branches. Float Black Plum on the right sides of the tree trunks and larger branches using the ¼-inch (6mm) angular. Load one of the three sides of the no. 8 trident brush's chisel edges with Evergreen by poking into the edge of the paint puddle. Tap on additional leaves, forming more definite leaf clumps.

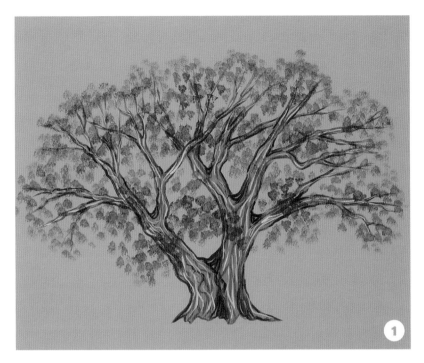

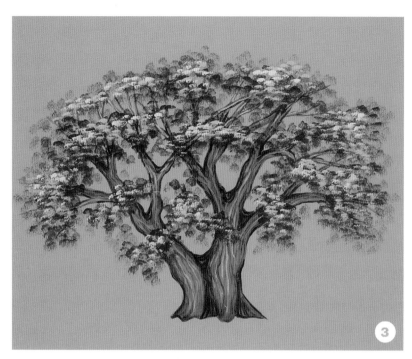

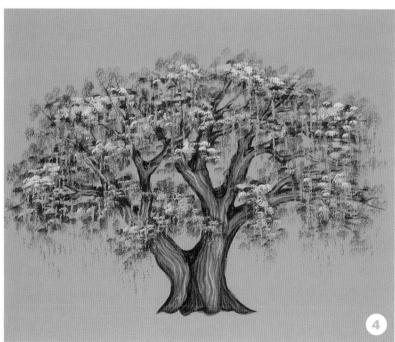

3 Again, load one side of the no. 8 trident as instructed in step 2 and paint Jade Green leaves on top of each leaf clump area. Do the same with a few Yellow Ochre leaves to highlight.

4 Spanish Moss: The Spanish moss is painted using the chisel edge of the ⅜-inch (10mm) blade brush, starting with Sable Brown. Tap the color vertically below each leaf clump, leaving plenty of space between each application. In the same way, add a few Soft Blue moss applications in with the Sable Brown.

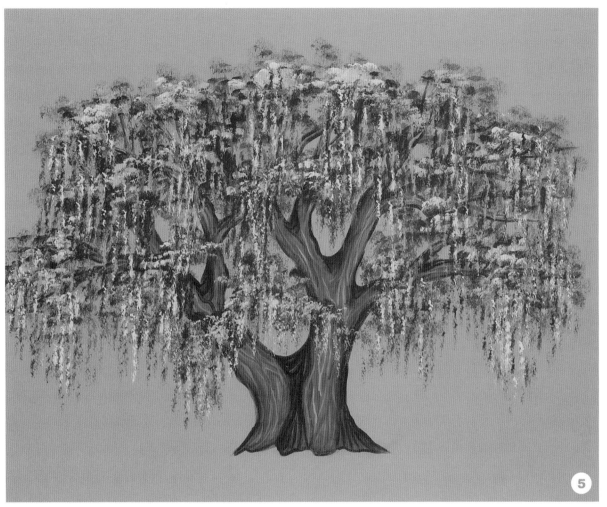

5 Spanish Moss: Evergreen moss is added in with the Soft Blue and Sable Brown applications, using the chisel edge of the ³/₈-inch (10mm) blade brush. The last color application is Yellow Ochre painted the same way. Notice how airy the leaves and moss have remained, because the "sky holes" were properly maintained.

Palm Tree

GREG ALBERT

MEDIUM: *Oil*

COLORS: *Burnt Umber • Viridian • Sap Green • Titanium White • Yellow Ochre Burnt Sienna • Cadmium Yellow Light • Lemon Yellow*

BRUSHES: *small round • small filbert • medium filbert • flat*

OTHER SUPPLIES: *solvent (turpentine, odorless paint thinner, etc.), Liquin, or a mix of one part turpentine, linseed oil and Damar varnish*

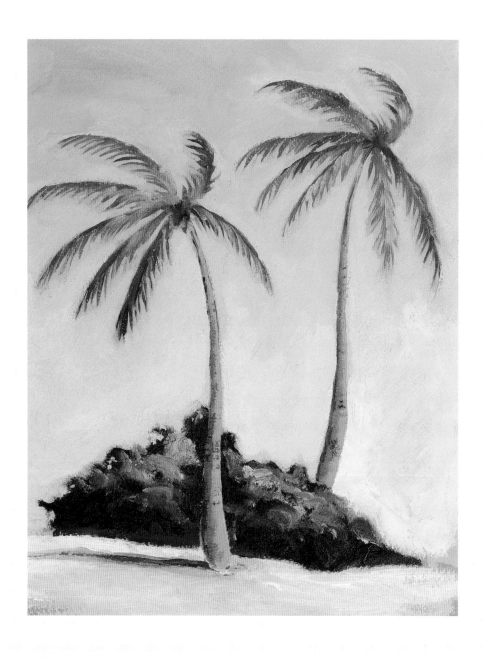

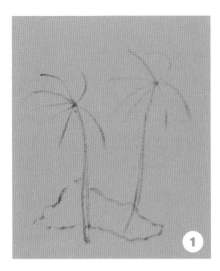
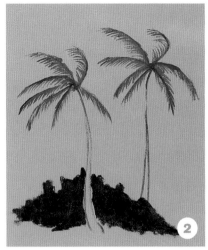
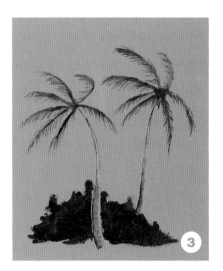

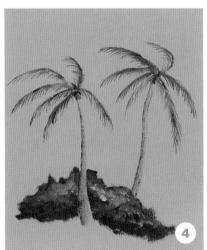

1 Using a small round brush and a thin mixture of Burnt Umber and solvent, draw the outline of the shapes lightly.

2 Block in any background foliage using a dark plant green. Viridian and Burnt Umber were loosely painted with a medium filbert brush. The fronds were painted with a thin mixture of Viridian and varying amounts of Sap Green diluted with a painting medium such as Liquin or the traditional mix of one part turpentine, linseed oil and Damar varnish.

3 Paint the trunks with Titanium White and Yellow Ochre with a small filbert or round brush. Add Burnt Umber or Burnt Sienna to match a specific subject. Indicate the side in shadow with Burnt Umber. Use a dry, flat brush to pull some of the shadow color across the trunk for texture.

4 Paint in the sunlit highlights on the fronds with a small round brush and Cadmium Yellow Light or Lemon Yellow. Be consistent with the direction of the light on the trunks. Use the same yellow and a small filbert to paint the upper parts of the background foliage.

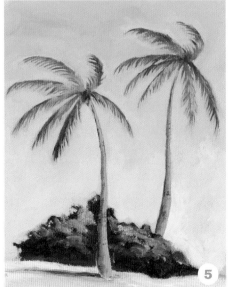

5 The finished palm tree. You can paint the tree over a previously painted sky color or paint the sky color around the finished tree. Either way, remember that the characteristic quality of the fronds is the rough edges created by the pointed tips of the individual fronds. Shadows should be cool because of the reflected color of the sky. Sunlight on sand should be indicated by an overall warm light color, depending on the local color of the sand granules.

tip *There are many different kinds of palm trees, each with distinctive fronds, trunk lengths and bark textures. Refer to source photos for specific details.*

Oak Tree with Lichen

BONNIE J. FREDERICO

MEDIUM: *Watercolor*

COLORS: *Black • Burnt Umber • Burnt Sienna • New Gamboge • Cobalt Blue*

BRUSHES: *no. 8 round • small round*

OTHER SUPPLIES: *masking fluid • sea sponge*

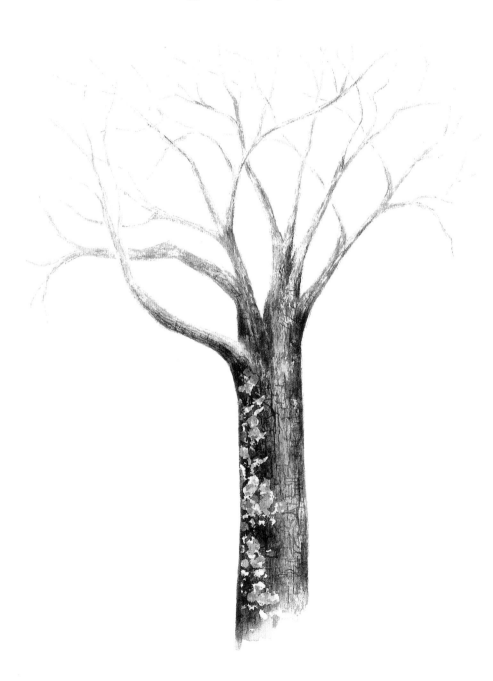

1

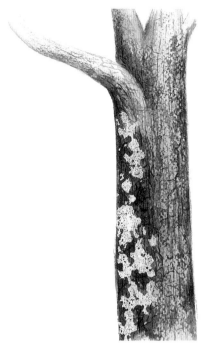

2

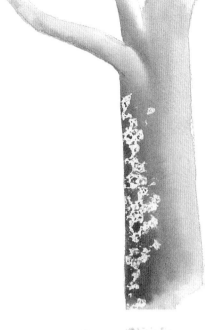

3

1 Using an irregular piece of sea sponge, dab on masking fluid where you want the lichen to appear. Dry completely. With a no. 8 round brush, apply a wash of Black + Burnt Umber to the left side of the tree. Lighten as you move to the right.

2 Drybrush the tree with Burnt Umber, Burnt Sienna and the basic tree color, using the no. 8 round. Then thin the Black + Burnt Umber mixture to an inky consistency. Create the bark by making a series of connecting horizontal and vertical lines, using a smaller round brush.

3 Erase the masking fluid. Drybrush with values of green made from New Gamboge and Cobalt Blue. Try to leave some of the white of the paper to create a lacy effect for the lichen.

Spring & Summer Tree

NANCY DALE KINNEY

MEDIUM: *Acrylic*

COLORS: *DecoArt Americana: Light Buttermilk • Fawn • Asphaltum Black Green • Hauser Medium Green • Celery Green*

BRUSHES: *no. 10 old, worn flat • Nancy Kinney's small dabber Loew-Cornell: no. 1 liner • ½-inch (13mm) wash*

OTHER SUPPLIES: *Jo Sonja's Retarder and Antiquing Medium*

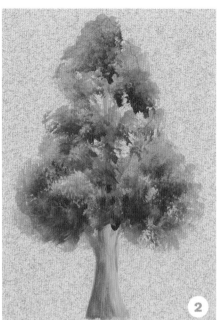

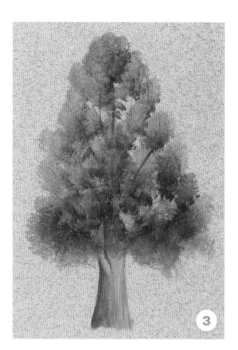

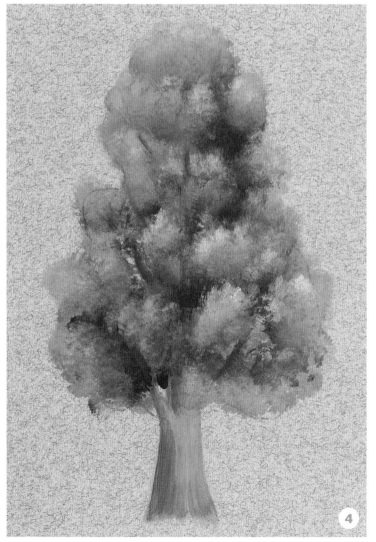

1 Base in the bare tree with two coats of Fawn. Using the liner, make a brush mix of Fawn plus Asphaltum. Continue painting tiny limbs, pulling from the larger branches. Lightly blend where the limb color meets the branch color. Let dry.

2 Use the ½-inch (13mm) wash to dampen the tree with retarder. Use the chisel edge of the small dabber and begin to darken the left side of the tree trunk with Asphaltum. Lighten the right side of the trunk with a brush mix of Light Buttermilk plus Fawn. Do not give too much detail to the branches because they will be covered with foliage. Double load the old, worn no. 10 flat with Black Green and Hauser Medium Green. With the Hauser Medium Green at the top of the brush, begin to tap in the foliage, beginning at the top of the tree and working to the bottom. Always keep the Hauser Medium Green facing up on the brush. Keep the foliage airy. Let dry.

3 Dampen with retarder. Using the liner, go back with thinned Asphaltum and add a few branches that show in the tree. This adds depth to the tree. Let dry.

4 Again, dampen the tree with retarder. Side load the old, worn no. 10 flat with Celery Green and begin to lighten the tree towards the top, middle and right side. Celery Green should be up on the brush as you begin to tap in the light value. While the tree is still damp from the retarder, further lighten with a touch of Light Buttermilk.

Weeping Willow

SHARON BUONONATO

MEDIUM: *Acrylic*

COLORS: *DecoArt Americana: Jade Green • Plantation Pine • Evergreen • Yellow Ochre Sable Brown • Asphaltum • Raw Sienna • Black Plum*

BRUSHES: *Sharon B's ³/₈-inch (10mm) blade • Sharon B's no. 6 halo • no. 1 liner no. 4 round • ¹/₄-inch (6mm) angular*

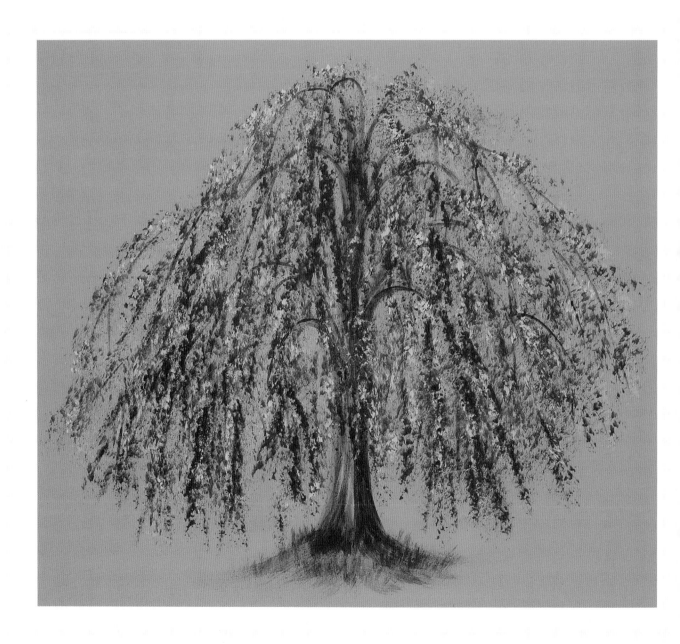

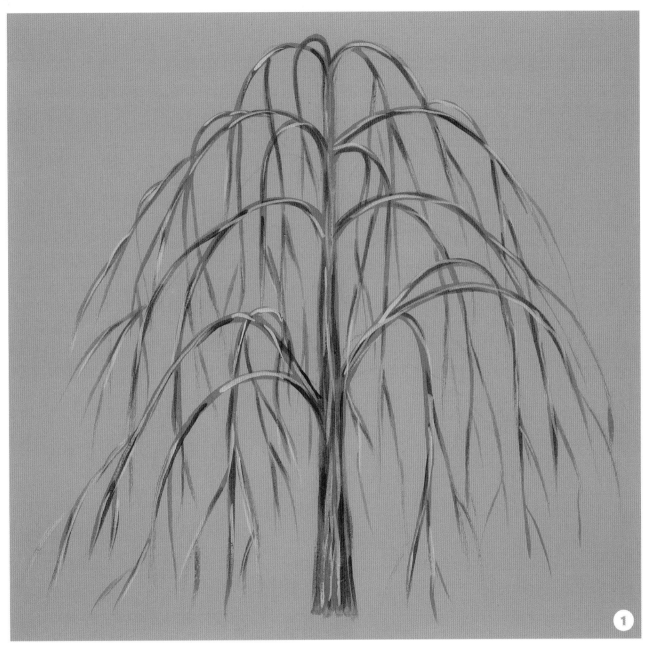

1 Paint the trunk and branches using Sable Brown and the no. 4 round and the no. 1 liner brushes. Shade the tree with Asphaltum linework, using the no. 1 liner. Highlight the same way using Yellow Ochre.

Weeping Willow CONTINUED

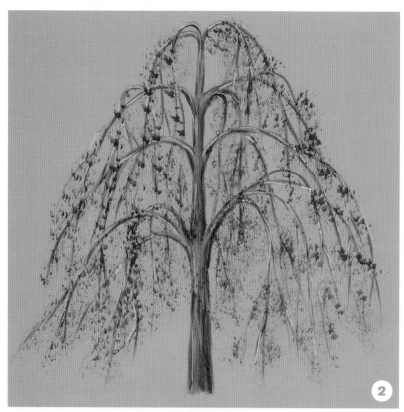

2 Wash over the tree with thin Raw Sienna to darken the trunk and branches, using the round brush. Float Black Plum on the right side of the tree, using the ¼-inch (6mm) angular. To properly load the halo brush, first draw a line of paint on the palette and tap across it. Load the brush halfway around, starting at the top of the angle chisel edge. Form delicate leaves by tapping Plantation Pine along the branches.

3 Add Evergreen leaves the same way, filling in the shape of the tree without losing "sky holes" and while keeping sight of the branches and trunk.

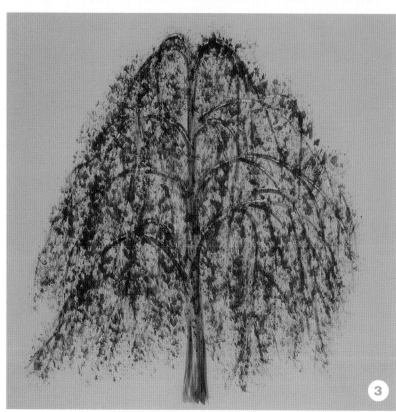

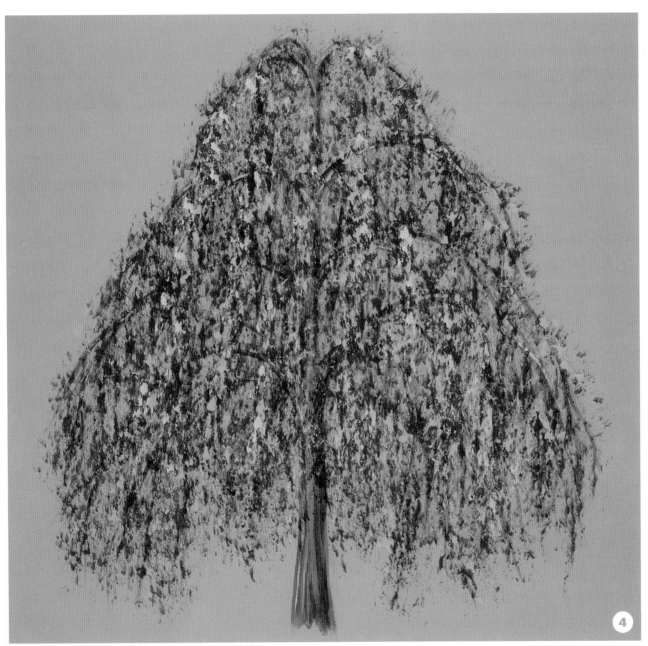

4 The highlights are painted using the chisel edge of the ³/₈-inch (10mm) blade brush and Jade Green. Tap the color on the center area of the tree vertically. Next add a few Yellow Ochre leaves the same way.

Autumn Tree

NANCY DALE KINNEY

MEDIUM: *Acrylic*

COLORS: *DecoArt Americana: Light Buttermilk ◆ Fawn ◆ Asphaltum ◆ Burnt Sienna*
True Ochre ◆ True Red ◆ Cadmium Yellow

BRUSHES: *no. 10 old, worn flat ◆ Nancy Kinney's small dabber*
Loew-Cornell: no. 1 liner ◆ ½-inch (13mm) wash

OTHER SUPPLIES: *Jo Sonja's Retarder and Antiquing Medium*

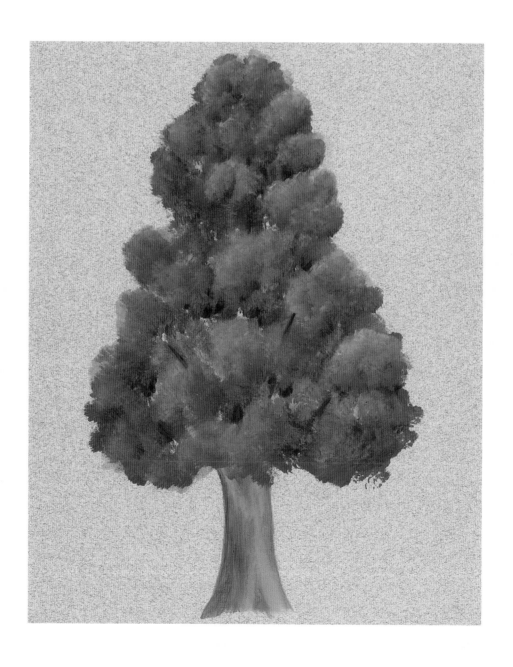

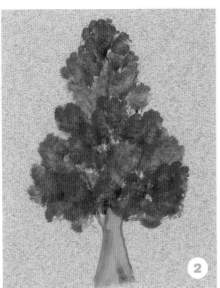

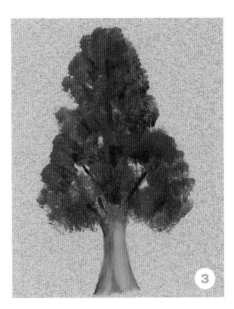

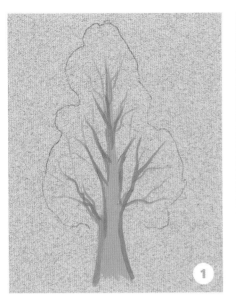

1 Base in the bare tree with two coats of Fawn. Use the liner to make a brush mix of Fawn + Asphaltum. Paint tiny limbs, pulling from the larger branches. Lightly blend where the limb color meets the branch color. Let dry.

2 Using the ½-inch (13mm) wash, dampen the tree with retarder. With the chisel edge of the small dabber, begin to darken the left side of the tree trunk with Asphaltum. Lighten the right side of the trunk with a brush mix of Light Buttermilk + Fawn. Do not give too much detail to the branches because they will be covered with foliage. Double load the old, worn no. 10 flat with Asphaltum and Burnt Sienna. With the Burnt Sienna at the top of the brush, begin to tap in the Autumn foliage, starting at the tree top and working to the bottom. Always keep the Burnt Sienna facing up on the brush. Keep the foliage airy. Let dry.

3 Dampen the tree with retarder. Using the liner with thinned Asphaltum, go back and add a few branches to show through. This will add depth to the tree. Let dry.

4 Again dampen the tree with retarder. Double load the old no. 10 flat with Burnt Sienna and True Ochre. With True Ochre up on the brush, begin to lighten the tree towards the top, middle and right side. True Ochre should be up on the brush as you begin to tap in the light value. While the tree remains damp from the retarder, further lighten by double loading the old no. 10 flat with Cadmium Yellow and True Red. With the Cadmium Yellow up, lighten on top of the True Ochre.

Autumn Maples

SHARON BUONONATO

MEDIUM: *Acrylic*

COLORS: *DecoArt Americana: Sable Brown ⋄ Asphaltum ⋄ Raw Sienna ⋄ Yellow Ochre ⋄ Pumpkin Bright Yellow ⋄ Cadmium Yellow ⋄ Cadmium Orange ⋄ Cadmium Red ⋄ Deep Burgundy ⋄ Black Plu▸*

BRUSHES: *Sharon B's ³⁄₈-inch (10mm) blade ⋄ no. 4 round ⋄ no. 1 liner ⋄ ¹⁄₄-inch (6mm) angular*

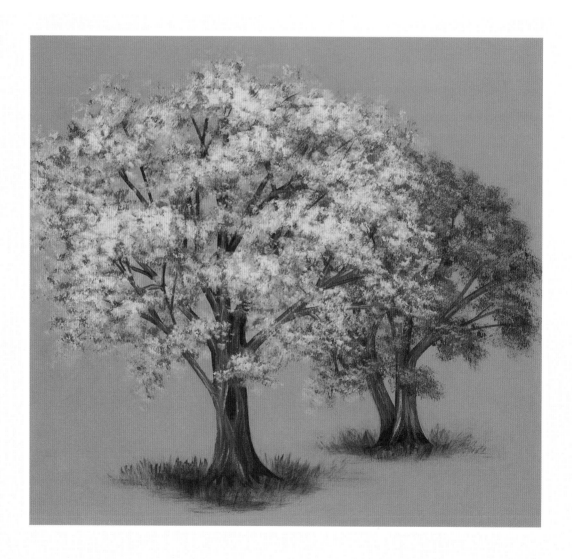

1 Midground Maples: Paint the trunks and branches with Sable Brown on the no. 4 round and the no. 1 liner brushes. Shade the tree with Asphaltum linework on a no. 1 liner. Highlight with Yellow Ochre in the same way. Tap Cadmium Orange leaf clumps, using the tip of the ³⁄₈-inch (10mm) blade brush. Leave plenty of "sky holes" for an airy appearance.

2 Midground Maples: Wash over the tree and branches with thin Raw Sienna on the no. 4 round. Float Black Plum on the right side of the tree trunk with the ¹⁄₄-inch (6mm) angular. Tap Deep Burgundy leaves on the base of the orange leaf clumps with the tip of the ³⁄₈-inch (10mm) blade brush. Do the same with Cadmium Red to the tops.

Autumn Maples

3 Midground Maples: Start connecting the leaf clumps by painting more leaves. Tap on Cadmium Red with the tip of the $^3/_8$-inch (10mm) blade brush, moving in a diagonal direction. Be careful to maintain "sky holes" where the branches and trunks are visible.

4 Midground Maples: Add delicate Pumpkin highlights by picking up less paint on the tip of the $^3/_8$-inch (10mm) blade brush. Add Deep Burgundy in the same manner to create a lacy appearance. To remove excess paint from the brush, tap on the palette. This will also separate the bristles.

5 Foreground Maple: Paint the trunk and branches the same as step 1, only larger. Bring the tree to the front of the composition by adding details such as a knothole and additional branches.

6 Foreground Maple: Follow the instructions for step 2, except paint the leaf clumps with Raw Sienna.

Autumn Maples

7 Foreground Maple: Following the painting technique in step 3, mix in Cadmium Orange leaves with the Raw Sienna leaves.

8 Foreground Maple: Following the technique in step 4, add two yellows to the Raw Sienna and Cadmium Orange leaves. Start with Bright Yellow (a yellow-green color). Then add plenty of Cadmium Yellow leaves as the predominant color.

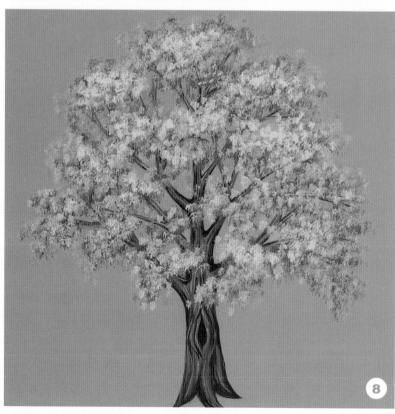

TREES

Familiar Tree Shapes (Silhouettes)

Lauré Paillex

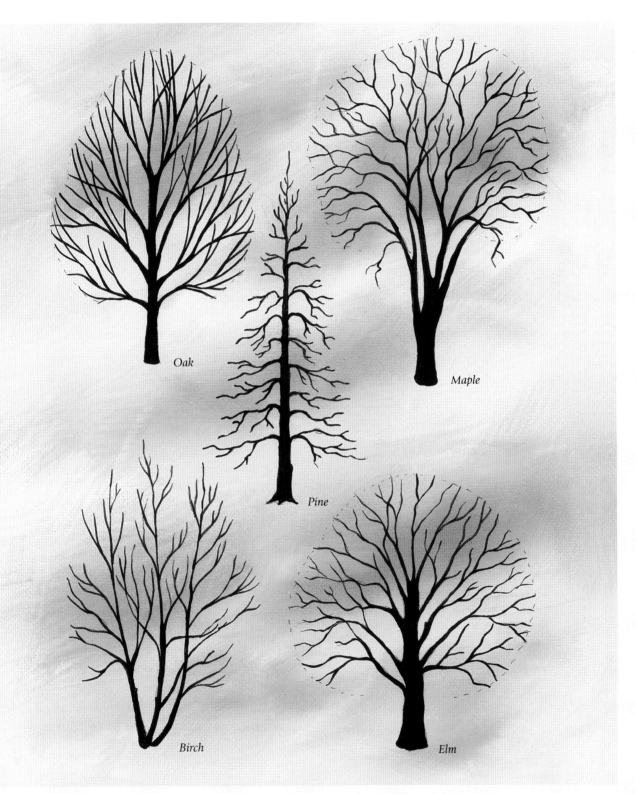

The purpose of this page is to offer a visual guide to some common tree shapes. It is useful to be able to recognize some basic shapes and understand how the foliage-shrouded trees are supported underneath.

Grasses

Grass adds the finishing touch to any landscape painting. In this chapter you'll learn how to paint varieties of grasses and how to paint grass from different perspectives.

Painting Grass Using the Angular Foliage Brush

LAURÉ PAILLEX

Drag

Crosshatch

DRYBRUSHING

Blot all excess moisture out of the brush before loading with paint. Wipe almost all paint from the brush onto a dry paper towel before applying strokes to your dry painting surface. Use light, even pressure on the bristles, gradually building layers of color until the desired effect is achieved.

Wet Surface

Dry Surface

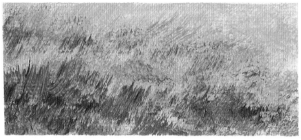

Stipple & Flip

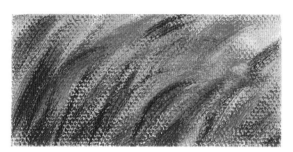

Pull-Toe

GRASS EFFECTS

For landscape paintings, load the brush with several colors and stipple (lightly pounce up and down) the paint onto the surface with the brush held horizontally on its knife edge. Apply this technique to a wet surface for muted, distance backgrounds or to a dry surface for a more textured appearance. To add detail, flip the bristles upward as you pounce. Use the loaded toe of the brush to produce wild field grass.

BACKGROUNDS

The resiliency of the China bristles and the angular slant of the brush shape make the angular bristle foliage brush ideal for surface preparation, background color application and underpainting. Use the brush-loading techniques described above to establish initial light and dark values as well as underlying texture and movement.

TEXTURAL EFFECTS

Use acrylic texture medium, alone or mixed with acrylic paint, for heavy dimensional effects. Acrylic decorating paste or thickening medium may also be used.

BRUSH CARE

Rinse the brush frequently and do not allow paint to build up at the base of the bristles. When done painting, clean the bristles thoroughly with cool, clean water and a good brush soap. Pay extra attention to paint residue that may have worked its way up into the metal ferrule. Rinse again. Flatten the brush back into its original shape and let air dry. For oils, use a suitable brush cleaner and treat as any fine-quality art brush.

Easy Foreground Grass

KERRY TROUT

MEDIUM: *Acrylic*

COLORS: *DecoArt Americana: Evergreen ◆ Midnite Green ◆ Olive Green ◆ Titanium White ◆ Marigold*

BRUSHES: *large flat ◆ no. 2 script liner*

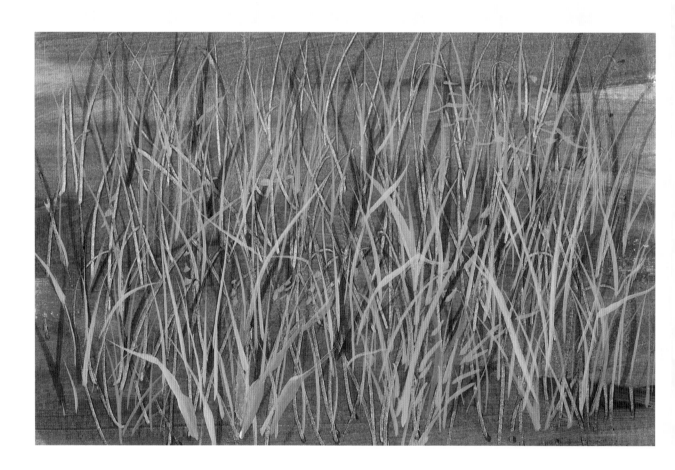

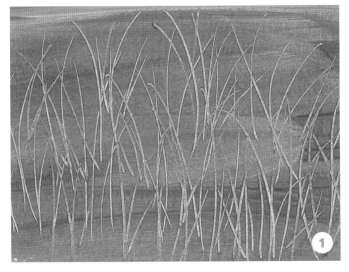

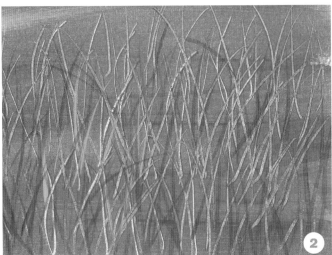

1 Basecoat grass area with Evergreen using a large flat brush. If you have a large area, work in small sections at a time, because you have to work with the paint before it dries (or add extender). With the end of a thin paintbrush, quickly stroke out blades of grass by wiping over the wet paint. Use quick strokes and make them very random, loose and soft. Grass isn't straight, so make each blade curved.

2 Use a no. 2 script liner and load it with a very watery mix of Midnite Green. Starting at the top of the grass area, begin stroking out blades of grass, from the ground up. Taper the grass by lifting up on the brush as you end your stroke. Cover your grassy area with these first strokes. When making grass, always start at the top of your area (the most distant grass) and work forward, or downward, overlapping grasses as you paint them. Remember that grasses will be longer the closer they come to the foreground.

3 Using the same brush and strokes, paint in more grass with lighter green, yellow and brown hues. Make your strokes long and curved, going every which way. Mix the colors on your palette to create a multitude of shades. This will make your grass look more natural and realistic. With the tip of your brush, dot in a few little buds and blossoms within the grass. In the foreground, make a few wider blades by adding pressure to the stroke, which will make your bristles flair and the grass blade wider.

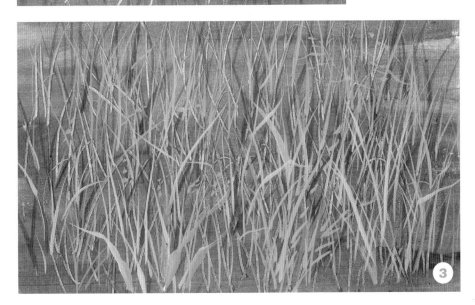

Field Grass

SHARON BUONONATO

MEDIUM: *Acrylic*

COLORS: *DecoArt Americana: Jade Green • Plantation Pine • Evergreen*
Yellow Ochre • Sable Brown • Asphaltum

BRUSHES: *Sharon B's ³⁄₈-inch (10mm) blade • 1-inch (25mm) flat*

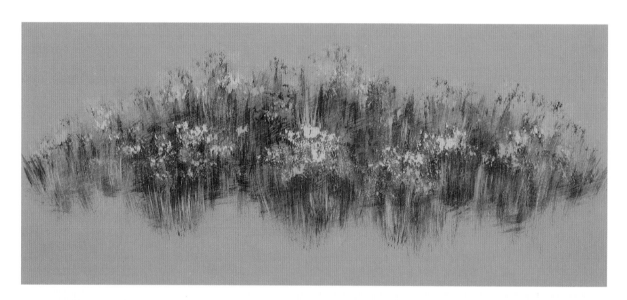

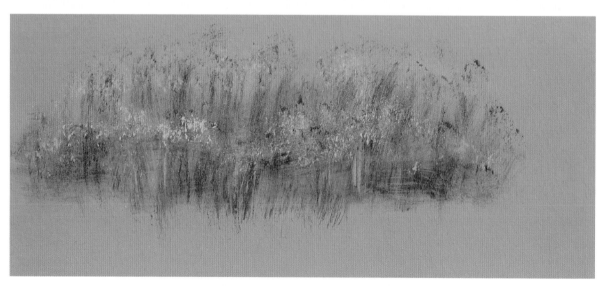

1 Midground Field Grass: Dampen the surface with clean water using the 1-inch (25mm) flat brush. While still damp, crosshatch Sable Brown to indicate dirt using the chisel edge of the ³/₈-inch (10mm) blade brush. Next, add in a few strokes of Asphaltum in the same way.

1 Foreground Field Grass: Follow step 1, of the Midground Field Grass instructions, but paint on a dry surface rather than a dampened one. The painting will appear darker and closer by slightly enlarging the dirt area.

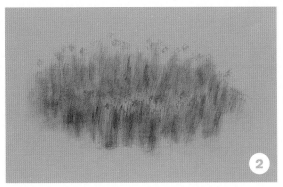

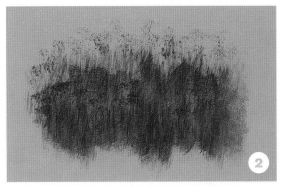

2 Midground Field Grass: Re-dampen the surface and paint vertical grasses using the chisel edge of the ³/₈-inch (10mm) blade brush and Plantation Pine. While still damp, add in Evergreen in the same way. Using the tip of the blade brush and both green colors, tap on delicate weeds at the tops of the grasses.

2 Foreground Field Grass: Follow step 2, of the Midground Field Grass instructions, but paint on a dry surface for a more defined appearance. Also, paint slightly taller field grass and more weed tops to cover the larger dirt area.

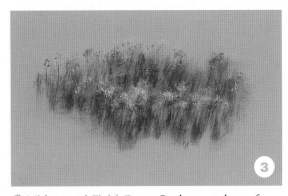

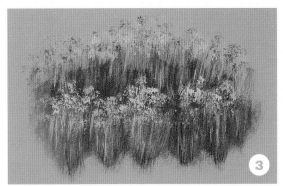

3 Midground Field Grass: Re-dampen the surface and paint vertical Jade Green grasses the same way. Add Jade Green and a few Yellow Ochre weed tops in with the previous greens, using the tip of the ³/₈-inch (10mm) blade brush.

3 Foreground Field Grass: Follow step 3, of the Midground Field Grass instructions, and paint more Jade Green and Yellow Ochre highlights and weed tops. Bring the field grass into closer view.

Distant Foliage

Adding distant foliage to your landscapes is another wonderful way to truly finish off a painting.

 This chapter will show you quick and easy ways to add trees, foliage and even a winter background to your artwork.

Foliage in the Landscape

KERRY TROUT

MEDIUM: *Acrylic*

COLORS: *DecoArt Americana: Silver Sage Green ◆ Light Avocado ◆ Avocado Evergreen ◆ Black Green ◆ Graphite ◆ Titanium White*

BRUSHES: *no. 12 flat shader ◆ no. 1 script liner ◆ ¼-inch (6mm) angular foliage ½-inch (13mm) angular shader*

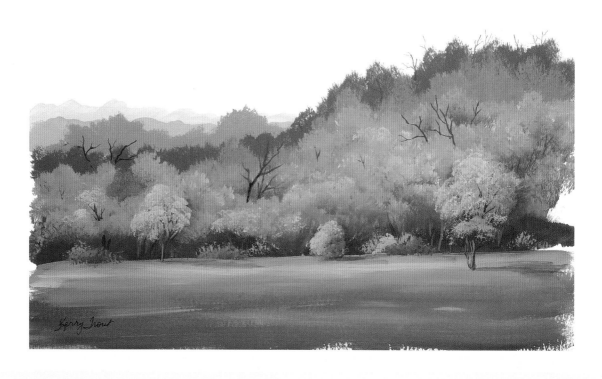

FOLIAGE

1

2

1 Along your most distant horizon, paint a line of foliage Silver Sage Green with a no. 12 flat shader. This line can be somewhat flat or scalloped, to suggest mountains. The bottom edge will be overlapped. Then drop your brush down a bit and apply another layer of foliage, adding enough Light Avocado to darken the first color just a bit.

2 Add another layer of Light Avocado with the same brush. Make the "highs" and "lows" in your layers very random. Allow one layer to go up over a previous layer in a few spots. This will simply show elevations in the tree line.

3

4

3 Bring your trees closer by starting another hill or tree line. Switch to a ¹/₂-inch (13mm) angular shader loaded with Avocado. Pounce this color across your tree line, but below the distant horizon.

4 Continue adding layers of trees in this manner, feeling free to change the colors as you go. Always drop down a bit when adding a new color to keep the layered look. Gradually get darker with your colors.

5

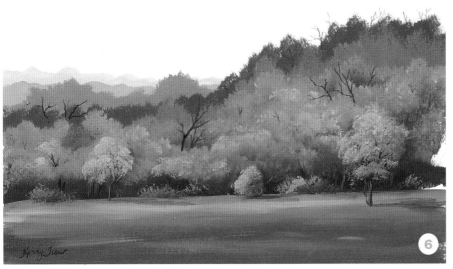

6

5 At some point you want to stop your foliage where it meets a road, meadow or other terrain. This line should be very dark, to suggest heavy shading. Pounce Evergreen mixed with Black Green (2:1) to this area.

6 Paint the distant grass against the deep shaded line with the no. 12 flat and Light Avocado mixed with Titanium White (2:1). Gradate the colors in the grass to become darker as they go down the painting. Use long horizontal strokes for the distant grass. Use a no. 1 script liner loaded with Graphite to pull out branches of dead trees amid the foliage and near the grass. Put a few trees and bushes close to the edge of the woods to soften that line. Add foliage to the trees by double loading a ¼-inch (6mm) angular foliage brush with Avocado and a touch of Silver Sage Green on the toe (tip) of the brush. Pounce these colors onto the trees with the lightest pounce, staying on one side of the tree (facing the light source). Stroke in some thin horizontal shadows beside the trees and bushes with Evergreen on the chisel edge of a no. 12 flat shader.

Distant Trees for Beginners

SANDY AUBUCHON

MEDIUM: *Acrylic*

COLORS: *DecoArt Americana: Graphite Grey ◆ Raw Sienna ◆ Rookwood Red ◆ Asphaltum*

BRUSHES: *no. 10 flat interlock bristle ◆ no. 0 script liner*

1 Fill the #10 flat interlock bristle brush with Canvas Gel. Dab one corner of the brush into dark Graphite Grey. Dab on palette. Stay dark to the bottom corner of the brush. Use the chisel edge of the brush and dab onto the canvas area.

2 Add a little Raw Sienna on the remaining corner of the dirty brush; dab on the palette to soften. Keep the Raw Sienna to the bottom corner of the foliage area.

3 On the Raw Sienna end of the dirty brush, add a little Rookwood Red. Dab on the palette and then apply to canvas. Keep the Rookwood Red corner of the brush at the top of the foliage area.

4 While still wet, rub across the bottom of the tree area with the dirty brush to set the trees into the ground. Use a #0 script liner with water and Asphaltum to apply distant trunks and tree branches.

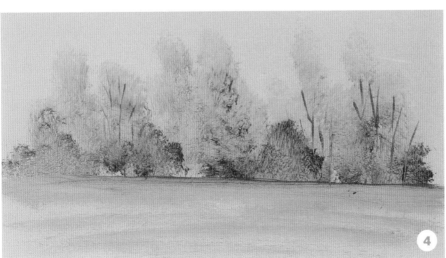

Winter Background

GREG ALBERT

MEDIUM: *Oil*

COLORS: *Burnt Umber* ⬩ *Cobalt Blue* ⬩ *Titanium White* ⬩ *Ultramarine Blue* ⬩ *Cerulean Blue* ⬩ *Gray*

BRUSHES: *medium filbert*

OTHER SUPPLIES: *solvent (turpentine, odorless paint thinner, etc.)*

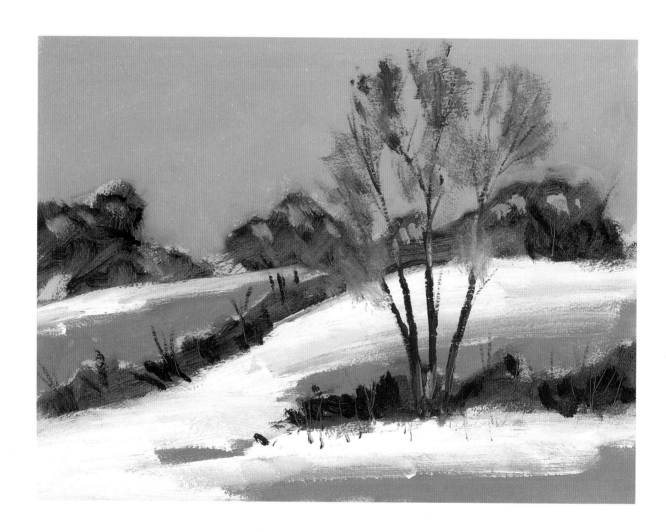

1 Block in the darker masses of trees and underbrush with Burnt Umber thinned with solvent and a medium filbert brush. Look for the simplified pattern of the larger shapes. Don't paint individual trees.

2 Block in the sky using a medium-sized filbert and Cobalt Blue and Titanium White mixed with a little Ultramarine Blue or Cerulean Blue to make either a warm or cool sky color. Note how the edges are soft and slightly inter-blended.

3 Block in the snow and shadow with Titanium White and the sky color. The tree in the middle ground was loosely indicated with the tip of the filbert, using a gray mixed with Burnt Umber and Ultramarine Blue. The same color with Titanium White was used for the small branches. Note how these were only suggested, not painted with individual strokes.

tip *Not every part of your painting needs to be painted in fine detail, especially backgrounds. Loose, soft-edged shapes won't distract the eye from your main focal points elsewhere in the composition. This demo is an example of how to paint a winter background so it remains in the background while suggesting a wintry scene. Keep it simple!*

Contributors

GREG ALBERT

Greg Albert is a well-known artist, writer and teacher. He paints in all mediums and specializes in landscapes and figure painting. He is the author of two art instruction books, both by North Light Books—"Drawing: You Can Do It" and "The Simple Secret to Better Painting." He teaches drawing and painting at the Art Academy of Cincinnati and conducts workshops around the country.

SANDY AUBUCHON, CDA

Sandy Aubuchon is an internationally-know artist, author and teacher. She has been painting for over thirty years and has published more than forty books. She teaches at conventions, demonstrates at trade shows and travels the world teaching classes and studying folk art painting.

SHARON BUONONATO, CDA

Sharon Buononato was first introduced to decorative painting in 1979 and started teaching in 1980. She became a Certified Decorative Artist in 1987. Sharon is the author of 5 books and 4 videos. She has also been featured in numerous painting magazines.

BONNIE J. FREDERICO, CDA

Bonnie Frederico has always loved art, but started her professional career as a math teacher. Her ability to teach others led her into the decorative art field. In 1994 she became a Certified Decorative Artist. Bonnie teaches at her home and at conventions in the U.S. and Canada. She has written "Fresh and Easy Watercolors for Beginners" for North Light Books.

ELIZABETH HAYES

Elizabeth Hayes has written 6 books on decorative art, including "Painting Luscious Fruit," by North Light Books.

She has recorded one video, teaches nationally at seminars and has been featured in numerous art magazines. Elizabeth currently lives in Pittsburgh, Pennsylvania.

NANCY DALE KINNEY

Nancy Dale Kinney and her husband, Doug are business partners and reside in Hickory, North Carolina. She has travel-taught for 25 years, both nationally and internationally, and has maintained a wholesale and retail business. Nancy also enjoys designing painted projects for home decor. She has authored 7 books.

LAURÉ PAILLEX

Lauré Paillex has been teaching decorative painting for over 25 years. She has authored numerous books, pattern packets, videos and contributes regularly to decorative painting publications. Lauré also exhibits and teaches around the U.S. and internationally, as well as at her home studio, Cranberry Painter Decorative Arts, located on Cape Cod, Massachusetts.

KERRY TROUT

Kerry is a self-taught artist who has been painting since she was a child. She is the author of four North Light Books; her most recent book is "Handpainted Gifts for All Occasions." She has recently begun selling her projects on CD-ROM.

TERENCE L. AND THEODORE C. TSE

Terence and Theodore Tse became involved with art in elementary school. As twins living and working closely together, they have almost identical experiences in the art field.

Resources

DecoArt Americana
P. O. Box 386
Stanford, KY 40484
www.decoart.com

Jo Sonja products; Chroma, Inc.
205 Bucky Drive
Lititz, PA 17543
www.chroma-inc.com

Nancy Kinney's Paintin' House
421 14th Ave. NW
Hickory, NC 28601
http://nancy_kinney.tripod.com

Loew-Cornell
563 Chestnut Avenue
Teaneck, NJ 07666-2490
www.loew-cornell.com

Royal & Langnickel Brush Mfg. Inc.
6707 Broadway
Merrillville, IN 46410

Sharon Buononato's brushes
SharonBsOriginals@worldnet.att.net

Index

North Light Books!

This book is the must-have, one-stop reference for decorative painters, crafters, home decorators and do-it-yourselfers. It's packed with solutions to every painting challenge, including surface preparation, lettering, borders, faux finishes, strokework techniques and more! You'll also find five fun-to-paint projects designed to instruct, challenge and entertain you—no matter what your skill level.

ISBN 1-58180-062-2, paperback, 256 pages, #31803-K

Let Michelle Temares show you how to develop, draw, transfer and paint your own original designs for everything from furniture and decorative accessories to walls and interior décor. "Good" and "bad" examples illustrate each important lesson, while three step-by-step decorative painting projects help you make the leap from initial idea to completed composition!

ISBN 1-58180-263-3, paperback, 128 pages, #32128-K

Learn how to enhance your paintings with the classic elegance of decorative gold, silver and variegated accents. Rebecca Baer shows you detailed gilding techniques with step-by-step photos and invaluable problem-solving advice. Perfect for your home or for gift giving, there are 13 exciting projects in all, each one enhanced with lustrous leafing effects.

ISBN 1-58180-261-7, paperback, 144 pages, #32126-K

With Maureen McNaughton as your coach, you can learn to paint an amazing array of fabulous leaves and flowers with skill and precision. She provides start-to-finish instruction with hundreds of detailed photos. Beautiful Brushstrokes is packed with a variety of techniques, from the most basic to more challenging, as well as 5 gorgeous projects.

ISBN 1-58180-381-8, paperback, 128 pages, #32396-K

These books and other fine North Light titles are available from your local art & craft retailer, bookstore, online supplier or by calling 1-800-448-0915.